DELTA
HOT TAMALES

DELTA
HOT TAMALES

HISTORY, STORIES & RECIPES

ANNE MARTIN | *Foreword by Elizabeth Heiskell*

To Lee + Angie —
So glad you found
the Delta! A Happy
Hot Tamales!

AMERICAN PALATE

Anne Martin
Delta Hot Tamale Festival 2025

Published by American Palate
A Division of The History Press
Charleston, SC
www.historypress.net

Copyright © 2016 by Anne W. Martin
All rights reserved

First published 2016

Manufactured in the United States

ISBN 978.1.46713.575.7

Library of Congress Control Number: 2016938317

To Valerie and Betty Lynn, the other two Hot Ta'Mamas

And to Mama and Daddy for introducing me to the joys of hot tamales

CONTENTS

FOREWORD

The smell of Joe's White Front Café tamales in Rosedale is the only smell that can transport me, mind, body and spirit, to somewhere other than where I am at that very moment. That aroma makes me happy and content like nothing else can. One whiff and I am climbing the rickety wooden steps into that iconic white building in downtown. One deep inhale and I am opening the screen door that is attached by one rusty hinge and one screw. Once the door flings open, it takes a minute for my eyes to adjust to the darkness. One exposed bulb on the ceiling is the only light source. Then the heat hits all at once.

I was a cautious eater. I always asked, before trying a new food, whether it was "heat hot" (hot because of the temperature) or "tongue hot" (hot because of the spice). This was my way of preparing myself and my mouth. When describing Joe's White Front Café tamales, I can safely say the heat is both.

When Daddy would head to the car with a big pot and a tight-fitting lid, I was not far behind. Lord, did I love riding with Daddy. But when the destination was Joe's, I was the first one in the car. Daddy drove a Ford LTD. It was the color of spicy brown mustard. The doors were as long as a flatbed truck and heavier than lead. Those doors were too much for a small child to handle. Daddy would take off in the car with my door wide open, and once we headed out of the driveway, he would cut the wheel just enough and at the perfect angle so that the heavy door would slam shut. It was Rosedale, and it was the '70s. As far as I was concerned, my daddy was a stunt driver. Hell, Evel Knievel had nothing on Will Gourlay.

I have often wondered why it was always the men who went to get the tamales. Could it have been because generally tamale stands were not in the best part of town? Could it have been that men loved tamales more than women? Could it have been that they sold ice-cold beer by the quart and always had a good game of cards going? You can decide for yourself, but I think I already know the answer.

No one is absolutely sure of the origin of the Delta tamale. Anne Martin does an excellent job of researching, tracking down and reporting all the legends of this food we love so much. Could the Delta tamale history be traced all the way back to the Mexican-American War? Perhaps soldiers brought back recipes. Were they born out of our rich American Indian heritage? Could it have been imprinted on the Delta by Mexican migrant workers who were brought to harvest the vast Delta crops? No one will ever really know, and all I can do is draw my own conclusions based on my life experiences.

The longest four hours of my life took place in a cotton field, chopping cotton for my father. I can still remember the agony of it. The minutes went by as slow as cold molasses. The ground was hotter than the hinges of hell. The only thing I was living for was lunch.

After a long morning in the fields, I can imagine the migrant workers sitting next to the African American laborers. The Mexican field hands ate warm, hearty, spicy tamales while the African American workers most likely ate cold, hard, dry biscuits with tiny slivers of salt pork. I do not know a whole lot about much, but I do know how this all went down. I am sure it was not long before the tamale recipe swap began.

Cornmeal and pork were staples in both the Mexican and African American workers' lives. These tamales were portable and could sustain the workers through hours of brutal work.

Tamale shacks and stands started popping up all over the Delta. Some people even sold them out of the backdoors of their homes to help make ends meet.

The Delta has changed in many ways, but the tamale tradition has remained unfazed and intact.

When I am asked where I am from, I always proudly say Rosedale, Mississippi. If the poor soul I am talking to does not know about the City of Brotherly Love on the banks of the Mississippi River, I get as excited as a preacher on Sunday morning about to share the gospel. I do not talk about the river or the levee or the courthouse dances. I tell them about Joe's White Front Café. I explain that Amy Evans and John T. Edge documented

Joe's White Front Café for Southern Foodways Alliance. They created a Tamale Trail highlighting the tamales at Joe's. I quickly tell them about the many magazine articles that have been written on our Delta tamales in such publications as *Southern Living*, *GQ*, *Garden and Gun*, *Gourmet* magazine and *Food and Wine*. Then I hound them until they agree to come visit.

If the Delta is the most southern place on earth, then tamales are the most southern food on earth. Many southern places have catfish, fried chicken and cornbread, but no place has tamales like ours. No place.

Elizabeth Heiskell
Chef
Featured on the *Today Show*
Owner, Debutant Farmer

ACKNOWLEDGEMENTS

When you live in the Mississippi Delta, everyone has an opinion about hot tamales. And none of them is wrong because hot tamales, after all, are a matter of taste. And a whole lot of tasting went on in preparation for this book.

First and foremost, I want to thank all of the hot tamale makers across the Delta and those with deep Delta roots who are keeping the tradition alive by making hot tamales by the dozens. Please continue to spread the love and the best food to ever come out of our corner of the world.

I will be forever grateful to Betty Lynn Cameron, my friend and former Main Street Greenville executive director, for checking her e-mail one day and discovering a message she had missed three weeks earlier from a publishing company asking if she knew anyone who might be interested in writing a book about Delta hot tamales. I sat in my car at the Sonic Drive-In in Cleveland, Mississippi, while contacting Candice Lawrence, commissioning editor at The History Press. In a matter of a few minutes, a lifelong dream began to turn into reality. See, it really does pay to read *all* of your e-mails.

Road trips to do interviews and shoot photographs were more fun with my partners in crime and dear friends Elizabeth Battle Long, Valerie Rankin and Debbie Leftwich. Along the way, we tasted a variety of tamales, got to explore a bit more of our beloved Delta and traveled backroads we never knew existed.

There are no words to tell Karl Wagner thank you enough for the beautiful artwork he created especially for this book. I am so honored he wanted to be

a part of this project. Besides leaving me speechless, he captured the essence of hot tamales on canvas in a way I never imagined. Karl, my friend, you are a true Delta treasure.

Debra Ferguson and Amy C. Evans were so generous in allowing me to use iconic photographs they had taken of some of our hot tamale pioneers. Thank you for capturing these moments in time. Also, Amy, thank you for the hard work and dedication you put into collecting the stories of the hot tamale makers across the Delta for the Southern Foodways Alliance Delta Hot Tamale Trail. This was an invaluable tool that I used while researching this book.

I am very appreciative of Main Street Greenville/Greater Greenville Housing for the use of the photographs from the Delta Hot Tamale Festival. Thank you for having the vision to continue honoring this simple food at the annual festival and embracing the title of Hot Tamale Capital of the World.

To the many friends who tried one of the numerous hot tamale creations tested in my kitchen, thank you for your honest opinions—and for helping me eat all those hot tamales.

And I apologize to all of our kids if it seemed like you were being fed hot tamales every time you came home, for asking you to taste yet another recipe using tamales and for subjecting you to hearing about one more hot tamale maker during visits and phone calls. Hallie, Kevin, Laura, Colton, Hampton and Kat, thank you for not complaining. Your love and encouragement are priceless.

Bill Vetrano, the love of my life, you supported me through this endeavor, which was a new one for us both. Thank you for being as eager as I was to taste-test even more hot tamales, for listening to my stories and encouraging me on this incredible journey. You will always be my favorite cook to share the kitchen with. And I promise, no more hot tamales for breakfast—at least, not for a while.

INTRODUCTION

I've been eating hot tamales all my life, though I don't exactly remember the first time I consumed one of these tasty morsels. But I think it is safe to say I must have liked them because I haven't stopped eating them since.

As a little girl, I have very fond memories of my daddy coming home with a gallon can that had been emptied and cleaned of its former contents and filled to the brim with hot tamales surrounded by their flavorful juice. They were packed in by the dozen, looking up at me just waiting to be devoured. When the can arrived home, it was usually covered with a few sheets of newspaper secured with a rubber band. While the paper might have kept the liquid from sloshing out of the can on the ride home, it did nothing to keep the aroma of those piping-hot treats under wraps. And that was a very good thing.

The minute Daddy hit the backdoor, we could smell them. We didn't have to be called to supper. My sister, brother and I descended on the kitchen, getting underfoot, clamoring for that Delta delicacy. As soon as Mama gave the go-ahead, silence fell over the table, except for the occasional exclamation of how good they were. The rattle of the paper unwrapping on a new sleeve of saltine crackers was the only accompaniment needed with hot tamales.

We ate until the can was empty. Leftovers were rare. And if there were any, there was a fight over who got the remaining hots. We couldn't get enough of them because we didn't know when we would have them again.

I didn't know a lot about hot tamales when I was a kid. I just knew that they were good and that I liked to eat them. I also knew you couldn't buy them at

the grocery store and that there was no recipe in any of Mama's cookbooks on how to make them. And I was never sure what kind of meat they were made of. Pork? Beef? The neighborhood cat? I couldn't tell. As a matter of fact, no one talked about what was really in a hot tamale, leaving customers to speculate on what exotic animal found its way into this treat. I grew up thinking it was one of those foods you didn't ask or think about—you just ate it. As I got older, I found out the truth. The neighborhood cat was alive and well while the pork and beef were being turned into hot tamales. It was all just part of the storied, mysterious life of the hot tamale.

For years, the only place we could buy hot tamales was from the famous Doe's Eat Place in Greenville, Mississippi, or from one of the few vendors with hot tamale–filled carts that could be rolled down the street. I recall an African American man selling hot tamales from his cart set up in front of the original Stein Mart Department Store on Washington Avenue in Greenville on Saturday afternoons. On occasion, Mama would come home with a couple dozen hots from the street vendor. They probably cost her about $4.50 a dozen. I also recall a man who sold tamales off the tailgate of his pickup truck backed into a parking space on the weekends near Stein Mart. (If you're asking, Why Stein Mart?, it's because that's where every woman in town came on the weekend to find inexpensive clothes for the family or fabric to recover a chair. And since mamas made the decision about what to eat, the hot tamale makers knew their tamales would do well anywhere in the vicinity of the discount store.)

In the late 1990s and up until the mid-2000s, I lived in Kansas City. That's when it became abundantly clear to me that hot tamales were a Delta thing. I asked around, and aside from the few puzzled looks I got, I was steered toward a couple Mexican restaurants. They had tamales all right, but nothing like the Delta hot tamale I longed for and craved to taste. How was my family going to survive without hot tamales? You never really know how much you are going to miss something until you can't have it anymore.

Trips back to Greenville suddenly had a new purpose. In addition to seeing my parents and friends, I had to have hot tamales. And it really didn't matter where they came from. On occasion, we would go to Doe's to eat tamales with a salad and steak. Or call Shine Thornton to pick up a couple dozen. But many times, I would call the Corner Market and order a couple dozen frozen hot tamales. They would be packed on ice in the cooler and make the nine-hour road trip back to the Land of Oz. It was one way to take a piece of the Delta with me.

And this is when I would introduce friends and co-workers to Delta hot tamales. No matter how hard I tried or how descriptive I was, they had no

idea what I was talking about until I showed them actual hot tamales and tasted one. Believers were made out of all who tried them.

My sister, Amy Williams Burton, reminded me of surprise hot tamale deliveries we would receive when we were little. Salvadore and Tilly Signa were our backdoor neighbors. Savy, as we called him, was the brother of Big Doe Signa, owner of Doe's Eat Place. Savy and Tilly would show up at our backdoor around supper time with a metal coffee can filled with hot tamales. We all got excited when the Signas showed up. We loved our neighbors, but our appreciation increased when hot tamales were involved.

"They would come in without warning. I was only about four or five years old, but I knew what was in that can with the tinfoil on top," Amy recalled. "That is my first memory of hot tamales."

The hot tamales, which had come from Doe's, quickly replaced whatever Mama was cooking for supper. When this would happen, whatever was on the stove or in the oven was turned off, and Mama would say, "Well, I've got supper ready for tomorrow night." The hot tamales did not wait.

As Amy told me this story, I had to ask her the same thing I've asked almost everyone I've talked to while researching this book: how do you like your hot tamales? Her response: naked. She doesn't want anything at all on her hot tamales, and that includes the cracker. She says she wants to experience the full flavor of the hot tamale without anything interfering.

She also told me about the time she and her husband, Keith, bought hot tamales out of the trunk of a car in Greenwood. "This was in the mid-'80s, and we couldn't find a good hot tamale in town. So we got them out of the trunk of a car," she explained. Just after their purchase was complete, a cop showed up. He said it was illegal to sell them like that if the guy didn't have a permit, which he didn't, and he needed to move along. Amy said she wondered what she had just bought but that the hot tamales were really good.

I remembered the first time I saw someone crumble their tamales over a salad at Doe's. I was with friends Lisa Burle Martin and Jodie Bledsoe and Jodie's mama, my other mama, Carolyn Bledsoe. As the famous house salad arrived, I noticed Jodie was waiting on something. She wanted her tamales. Once they were on the table, she quickly unrolled a couple, broke them into bite size pieces, placed them on top of her salad, poured chili over it all and added some shredded cheese: instant tamale-chili salad. I was impressed. I've since copied this ritual at Doe's and at home.

Over the years, hot tamales have become more available between Memphis and New Orleans and across the state of Mississippi. More restaurants serve them now. More vendors make and sell them out of

their homes. Hot tamale stands are set up in high traffic areas in the communities. The recipes are still closely guarded, but some hot tamale cooks have ventured beyond pork and beef to include fruit and vegetables and even catfish or shrimp in their recipes.

But a couple things haven't changed. They are still mostly made by African Americans, and they still taste wonderful. There is something about eating a hot tamale that evokes smiles. It is the food we claim as our own here in the Mississippi Delta. They are simple and simply delicious.

WHAT IS A HOT TAMALE AND WHERE DID IT COME FROM?

How the Hot Tamale Found Its Way to the Mississippi Delta

Hot tamales became very much a Delta food. Hell, we were eating them before I ever recall seeing a Mexican.
—*Shelby Foote*

To understand hot tamales, you must first understand the Mississippi Delta. A flat land stretching out as far as the eye can see, it was once a swamp covered in cypress trees, water, alligators and mosquitoes. Hearty pioneers cleared the land and knew the earth would be good for growing crops. The Delta is an alluvial plain of rich soil that gives life to soybeans, corn, rice and the once king of agriculture, cotton. Nestled along the western edge of the state between Memphis and Vicksburg and bordered by the mighty Mississippi River on the west and the hills on the east, the Delta spans across Mississippi and Arkansas. Noted Greenville writer David Cohn penned in *God Shakes Creation*, "The Delta begins in the lobby of The Peabody Hotel in Memphis and ends on Catfish Row in Vicksburg."

The history of the Delta is rich, a place where loyalty runs deep and tradition is revered. It is the birthplace of the blues, home to B.B. King and a sometimes home to William Faulkner. The fish are big and the tales even bigger, and neither is served without a cocktail in hand. Something is celebrated every day, and it doesn't have to be anyone's birthday. The sun coming up is reason enough. The minute two or more folks get together, one of two things is about to happen: church or a party. And if it's a party, the first two things you will be asked are "What do you want to drink?" quickly

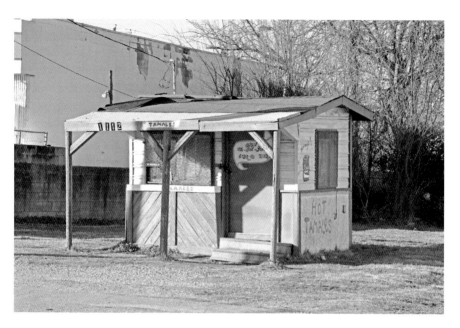

Small hot tamale huts like this one dot the Delta landscape. Many are open, though others, sadly, have closed. *Author's collection.*

followed by "Can I get you something to eat?" Delta folks love to do both, especially together. You won't have to look hard to find hot tamales served at any Delta party, no matter how big or small, how elegant or casual.

They will be served right alongside the ham biscuits and the shrimp dip. Hot tamales are a staple at church potlucks and family gatherings and have been known to show up at the homes of the bereaved. Regardless of race or economic status, hot tamales are a favorite with just about everyone.

Ride around any Delta community, and you won't have to look far to find a hot tamale stand. They usually aren't very big because most times the tamales aren't cooked there. Or ask who makes them and most likely you will be pointed to someone's house where the hot tamales are made in the kitchen and sold out the side door.

Even the State of Mississippi knows how important hot tamales are. A state tourism booklet highlighting various places to see and things to do has called the tamale one of the more unexpected official state delicacies.

As much as the Delta loves its hot tamales, their history isn't crystal clear. One of the biggest mysteries about hot tamales is where they came from. The suggestions are as varied as the recipes used to make them. Many believe tamales are of Hispanic origin and were a part of that culinary

heritage. They were served not only in homes but also as street food. As time passed, the tamale found its way to other countries, crossing the border into the United States when migrant Mexican workers were brought here in the

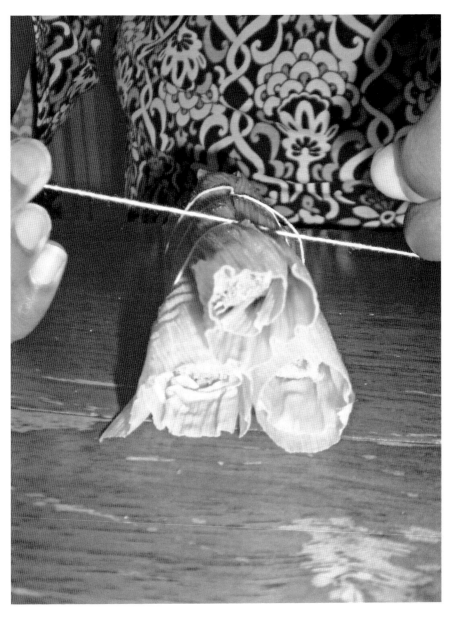

Three hot tamales are tied with string, creating a bundle, the perfect size for a tamale snack. *Author's collection.*

early 1900s to work in the fields picking cotton. Known simply as tamale, or *tamal*, the food was portable, easy to prepare and could be taken to the field. Working alongside African Americans tending to the crops, Mexicans shared their food made of pork and masa. It wasn't long before tamales were being made by African Americans, who changed the recipe to fit their tastes and availability of meat and cornmeal, evolving them into the beloved hot tamales we savor today.

Some believe tamales arrived here following the Mexican-American War, when U.S. soldiers from Mississippi who had traveled to Mexico brought the recipe back with them.

Others believe Delta tamales developed from a generations-old African American dish called cush. According to the Southern Foodways Alliance (SFA), a tamale vendor in Yazoo City talks about cush in his interview: "Some say [hot tamales] come from an old word that we use called *cush*, you know. A lot of the Africans would just take meal and season the meal because a lot of them didn't have enough money to buy meat like they wanted, so they would take the meal and season the meal."

And there are those who say the tamales have always been a part of the Delta, claiming Native Americans who settled in the area are responsible for the delicacy. This could be possible since these natives were an agricultural tribe who worked with maize, or corn. If the Native Americans were growing corn, then there would have been plenty of shucks for wrapping the hot tamales.

There are even a few folks scattered around who say the Italians had a hand in bringing tamales to the Mississippi Delta. The theory goes that the Italian population was traveling down the river, swapping recipes along the way with migrant workers. This could be the case, but as documented in the SFA oral history project of the Hot Tamale Trail, the Delta was built up by a lot of people who were just travelers going from one destination to another, according to Larry Lee, a former salesman at Greenville's Hot Tamale Heaven.

"That's how the people melted here. And from that, you get all kinds of cultures and ideas," Lee said during his oral history recording with SFA's Amy Evans. "You share with me, and I share with you. Before long, what can I tell you? Something came out of it, and the tamale was one of those things."

As the Mexican laborers worked alongside the African American workers, the Delta tamale began to take shape. The Delta tamale is smaller than its Mexican cousin. Today's hot tamales are about five to six inches long and are tubular in shape, resembling a slender cigar. They are also believed to

For years, hot tamales were sold only from a cart or someone's home; however, today, more signs like Larry's are popping up. *Author's collection.*

be more flavorful, spicier than the Mexican version. And they are usually made with cornmeal as opposed to the finer masa. Seasoned, well-spiced beef or pork is usually the filling for the tamale. The word *hot* in hot tamales shouldn't be taken too literally. While they are expected to have a nice taste, not all hot tamales are hot in flavor. While the Latin *tamal* is steamed, the Delta tamale is simmered in liquid, which may or may not include additional spices. This creates a juice to keep the tamales moist and flavorful. This is how the hot tamale started out, but now makers are becoming bolder and more adventurous by using different meats and even some fruits and vegetables.

Robert Stewart, a hot tamale maker from Bolivar County, told the SFA it's all about the taste. And that, to him, means spicing up the meat and the dough: "See, with the spice in the dough and the meat, then when it comes together, it's better. Because when you first bite it, you're going to bite the dough anyway, so why not make the dough spicy?"

What started out as a portable food for farm laborers has become a beloved food staple of the Mississippi Delta supper table.

Recipes for the tamales vary from place to place and person to person. No two recipes are alike. The ingredients may be the same, but the amount

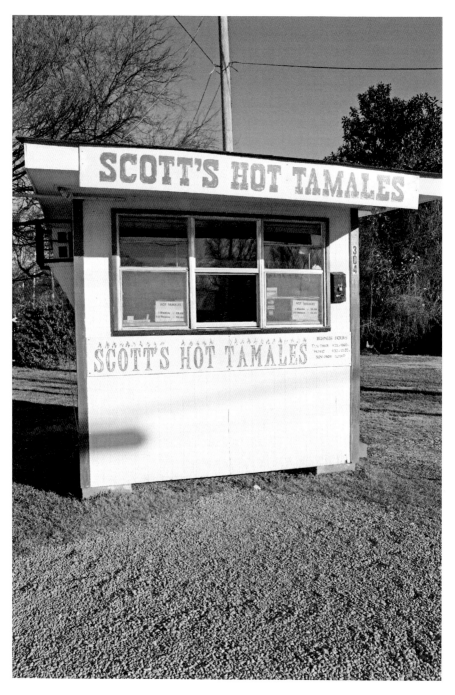

More than sixty years of love and labor have gone into making Scott's Hot Tamales a mainstay in the Mississippi Delta. *Author's collection.*

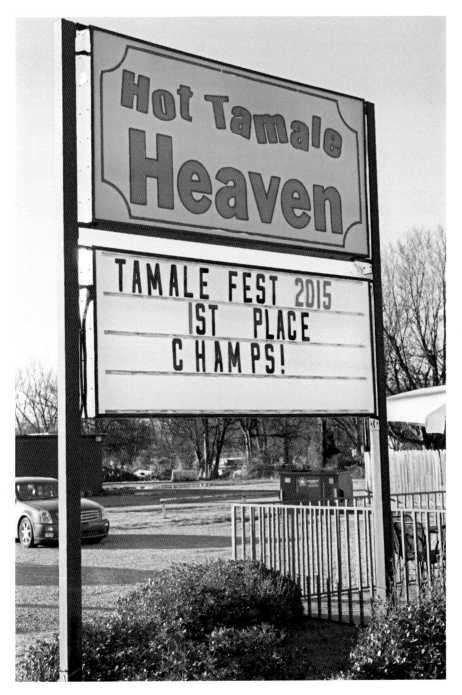

Hot Tamale Heaven shows off its pride from the 2015 Delta Hot Tamale Festival. *Author's collection.*

can be totally different. Pork and beef are the preferred meats, but some use turkey, venison and even shrimp or vegetables. Some folks even fry their hot tamales.

So after all the spices, masa versus cornmeal, how do you eat a hot tamale? Any way you want to! There is no proper way to consume this little piece of culinary heaven. Some like to eat it plain, right out of the shuck. Others smother it with warm chili sprinkled with cheese.

But why have they stayed here and not spread to other areas of the state and country the way, say, the hamburger has? The only plausible explanation is the recipes have been so closely guarded. Once a recipe is perfected, the holder protects it, not sharing it with anyone; some even take it to the grave. Others have been known to give up the secret only on their deathbeds.

In addition to the secretiveness, it's not an easy process to make hot tamales. No matter how you try, they take two days to make: one to cook the meat and the other to make and roll them. African Americans saw hot tamales as a way to not only feed family members headed to the field for the day but also make money. The majority of hot tamale makers today are African American. For the most part, they are keeping the tradition of hot tamales alive and well in the Mississippi Delta and in a few regions outside the area.

For generations, hot tamales have persisted in the Delta because of public demand and tradition. It doesn't matter where they came from; they are a staple. African Americans discovered a food that was portable and filling to take to the field, and in the process, an opportunity arose to help provide for a family after the harvest was over. More hot tamales are sold during the cooler months, but they are consumed year-round whenever the urge hits. One thing is for sure: no matter how they are cooked or where they came from, the Delta has claimed hot tamales as its own for years.

Hot tamales have been immortalized in blues songs. They have found their way into other dishes, such as hot tamale dip and tamale sandwiches, which is three tamales between two pieces of white bread. You can even get them deep fried.

From Memphis to Vicksburg, hot tamales are a favorite food. And whether you suck them out of the shuck or unroll them, they are as much a part of the Delta as the river and cotton.

In his SFA interview, Lee concluded, "The best way I can sum it up is that you're not from the Delta if you know nothing of tamales. It's that simple. It's the levee, it's the blues, it's the tamale."

And it's our Delta.

Chapter 2

HOT TAMALES ARE RED HOT

The Folks Who Make Hot Tamales

It really is like this rich, magical story packed in a corn shuck.
—Susan Puckett, author Eat Drink Delta:
A Hungry Traveler's Journal Through the Soul of the South

Their eateries bear names like Lost Cat, Sho Nuff, Queen City Rollers, Hot Tamale King, Aw Shucks!, Deep in the Maize, Mr. Hot "T" Molly and Papa Doc's Big Fat Tamales. They make their tamales in the kitchens of homes and restaurants. The process is tedious, time consuming and rewarding. The folks who make hot tamales took on this task for a variety of reasons. Some developed their own recipes while others inherited theirs from parents and grandparents only after swearing to never share it with anyone. Some recipes have gone to the grave, lost forever. These recipes are not found in your mother's cookbook. They are stored in the minds of those who create this culinary delight.

But the men and women whose hands shape each tamale are part of a select group of culinary historians. They are continuing a tradition that began decades ago, a tradition that really has no beginning; it just was, and it continues to attract Delta folk and foreigners alike. They are the hot tamale makers.

These are their stories.

DELTA HOT TAMALES

MARIA'S FAMOUS HOT TAMALES

Lawrence "Shine" Thornton, Greenville

Lawrence "Shine" Thornton began making hot tamales at his Greenville home in 1984, when he lost his job of thirty-seven years at Delta Electric. He also owned a liquor store, but he knew selling whiskey and wine wasn't going to support his family. That's when he got into the hot tamale business. "It took me a while to get the recipe just the way I wanted it," he said in a 2011 interview. "I used to always tell folks hot tamales is like corn whiskey: you never get the same thing out twice. Makes no difference what you do, it won't never come out the same twice."

But after years of practice and thousands and thousands of hot tamales later, Shine perfected the recipe, and they come out the same each and every time now.

Shine used cornmeal for his tamales, along with some of the broth from the meat. He then fed the meat and the cornmeal mixture into the tamale-making machine, which wraps the meal around the meat. Even his hot tamale–making machine is special. It was made in 1937.

Shine sold tamales from his car and a van and peddled them around town at different locations. But once he got his custom kitchen built behind his house, folks just called him up and placed orders.

It wasn't long before Maria's Famous Hot Tamales was in business. He named his new venture after his beloved wife, Mary, using the Italian version as a nod to her family heritage. Shine said he worked hard to make the best hot tamale around. An older black gentleman from the neighboring town of Metcalfe used to sell his hot tamales in Greenville on Saturdays. After tasting one of Shine's hot tamales one weekend, he told the new hot tamale maker not to change a thing; his recipe was good. Shine said he didn't change anything major, but he never stopped tweaking the seasonings here and there.

He constructed a building behind his house where he made his hot tamales after the health inspector said he couldn't make them in his house anymore. Shine said he later found out the health inspector lied to him, that folks were still making and selling hot tamales out of their homes.

Folks would call him up, place orders and come to the little house to pick up their hot tamales. In the beginning, they would bring pots big enough to hold a couple dozen or more hot tamales. He later used Styrofoam containers. On occasion, if the tamales had not been simmered, he would

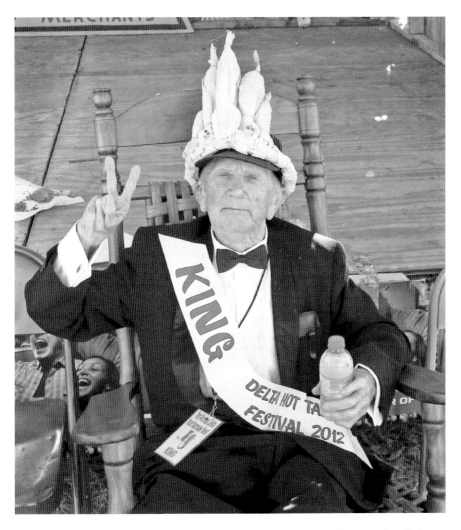

Shine Thornton, beloved Greenville tamale maker, reigned as king of the very first Delta Hot Tamale Festival. *Main Street Greenville.*

give his customers a packet of seasoning mix to add to the water with a slip of paper outlining the instructions on exactly how to do this.

Shine preferred using beef, instead of pork, to make his tamales. He said he was scared of pork, afraid it would spoil in the summer. He simmered his tamales and would add more seasoning to the water to enhance their flavor. He used a machine to make his hot tamales from the very beginning. He said he couldn't have done it without the machine; it made the production faster. On the weekends, Shine would load up his van with hot tamales, stake out

a corner along U.S. Highway 82 near his liquor store and sell them until he ran out.

His recipe was so good that he won first place in the World Championship Hot Tamale contest for several years. The first year he won, he got a big belt buckle declaring him the winner.

"I was so proud," he said. He even tried to get his hot tamales delivered to the White House. He had heard President George W. Bush was a big fan of tamales. Maria's Famous Hot Tamales never did make it to the White House despite Shine's best efforts to get them to Washington. Shine didn't get rich off hot tamales, but he was able to support his family. He said he never did write down his recipe. He was afraid someone was going to steal it.

Shine became so synonymous with hot tamales that he was crowned the first king of the Delta Hot Tamale Festival in 2012.

"I was fifty-nine years old when I started making hot tamales," Shine said. "I did this to help my family, but I love doing it. I love everything about hot tamales."

Shine loved his hot tamales, and he loved Greenville. But his hot tamales and his infectious smile both came to an abrupt end in October 2013, when Shine died unexpectedly. He was attacked and robbed in the driveway of his home the day before the hot tamale festival. He told the paramedics and the hospital staff he had to get back home so he could attend the Delta Hot Tamale Festival the next day. Ready to take his place as the ex officio king, he even had his tuxedo laid out on the bed. Word of his death came as a post-festival brunch was taking place.

RHODA'S FAMOUS HOT TAMALES AND PIES

Rhoda Adams, Lake Village, Arkansas

Rhoda Adams has been selling hot tamales in her small Lake Village, Arkansas restaurant for forty-six years. Her husband's aunt Laura Bowling taught her how to make hot tamales, although, at first, she was reluctant to learn. Over the years, she has developed her own recipe, which she shares with no one.

"I don't tell anybody how I make my hot tamales," seventy-six-year-old Rhoda said. "But everybody tells me they like mine the best."

Rhoda's hot tamales are made from a mixture of beef, pork and chicken. That's about all she is willing to share.

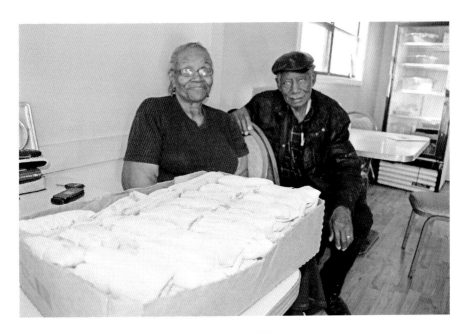

Rhoda and James Adams keep customers in Lake Village, Arkansas, happy with hot tamales and homemade pie. *Author's collection.*

When asked what makes her hot tamales so special, Rhoda exclaimed, "Because I'm special!"

Rhoda prides herself on taking care of her customers. On the day I visited her store, a man walked in the door late in the afternoon and wanted hot tamales. But there weren't any ready. Rhoda and her husband, James, were about to put a large box of frozen tamales in their car to take home to get ready for cooking. She could tell the customer really wanted some of her hot tamales. After first telling him he would have to come back the next day, she stopped him as he headed for the door. She finally offered to cook some at home and meet him back at the store in a couple hours. He was extremely grateful.

"God gave us the talent to take care of our family," James said. "It's been a good living."

Even though they sell the tamales at their business, Rhoda still loads up the car some days of the week and sells them outside area businesses.

Rhoda says people tell her all the time how much they love her tamales. And for that, she says, she is very thankful.

Larry's Hot Tamales

Larry Turner, Clarksdale

In Clarksdale, two tamale makers sit at either end of the bridge that crosses the Sunflower River on State Street. Larry Turner has been around hot tamales all his life and says he learned how to make them without knowing he was learning.

"When I was thirteen or fourteen years old, I had a neighbor who made them, and I would help him," Turner said. "And I was

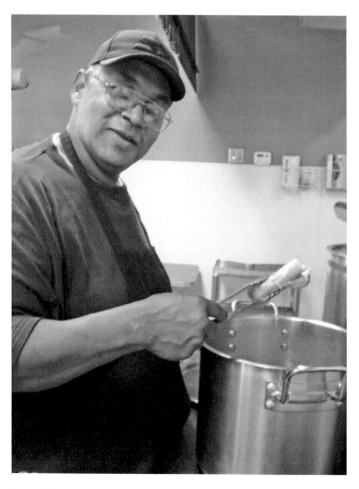

Larry Turner calls hot tamales a happy food that should be tried at least once and eaten often. *Author's collection.*

learning how to make them the whole time." That was forty-five years ago, and he says the basic recipe stuck with him.

While in the air force in the mid-'70s, Turner said he knew he wanted to make hot tamales one day. And in his head, he was always working on the recipe. Wherever the military sent him, he was searching out tamales to give them a taste. After his stint with the military was up, Turner began making hot tamales with the recipe he had. Once he returned to Clarksdale, he began to tweak the recipe into the one he uses to this day. He adjusted the ingredients until he liked what he had and began making and selling his hot tamales at his mother's restaurant, Turner's Grill. But it wasn't until 2008 that he began his own hot tamale business.

Larry's Hot Tamales is located near the corner of State and Sunflower Streets. He uses a machine to form the meat mixture into a tube and wrap the cornmeal mixture around it. His all-beef tamales have a nice spicy flavor and are simmered in a thicker juice than most. Turner says some folks come in just to get the "sop," as he calls it, by the jar. "It's great flavor to be sopped up with some good bread!"

Turner says he's not sure why folks like hot tamales so much. But he calls them a happy food that is part of the Delta. "This has always been my dream, to make my hot tamales and sell them.

"People like a quick food, finger food, and the hot tamale fits the deal all the way around."

Turner says the uniqueness of the food is also why folks love it. Like those of most tamale makers, his recipe is closely guarded. Besides himself, his brother and a friend in Tennessee know how to make the tamales. He says he hasn't changed his recipe in years, although it is different than the one he used when he learned how to make tamales.

"Some ingredients you can't find so easily like you could back then, so you have to find a substitute."

HICKS FAMOUS HOT TAMALES

Eugene Hicks Sr., Clarksdale

On the other end of that bridge that crosses the Sunflower River, things are a bit more hands on. At Hicks World Famous Hot Tamales, Eugene Hicks rolls the cornmeal mixture around the tamales by hand. He's been doing it

that way for fifty-five years. He uses the tamale-making machine to shape the beef mixture. The meat is then chilled for easier handling as it is rolled in the seasoned cornmeal mixture.

"I like to do this part by hand so it doesn't make the meal mixture so thick. I want you to taste more meat," Hicks said. He uses beef to make his tamales, which are placed back in the refrigerator to once again chill before being rolled in the corn shucks.

Hicks has been hands on the entire time he has made tamales. Betty Hicks said there is a skill to making hot tamales, but it is tiring. She helps put the tamales together, but her husband is the only one who handles the seasoning process.

"He won't even tell me the recipe or show me how it's done," she said with a smile. "And we've been married forty-six years."

"No one on the face of the earth has ever handled the seasoning of my tamales," Hicks confirmed. "I can't take that chance that it won't be right."

On the day I visited him, Hicks had made forty-five dozen hot tamales. He showed me a specially designed board he made to help with the production process. He designed the board to hold the tamales upright for tying. It's a long, thick piece of wood with thirty-six holes, each three inches in diameter. Three tamales can stand in one hole for easy tying. When the board is full, he knows they have tied nine dozen. The bundles are tied with plastic twist ties as opposed to cutting and tying string.

"I came up with the idea of this board. It just makes it easier to tie them. It's quicker for one person to handle," he said.

At twelve years old, he learned how to make hot tamales. By fourteen, he was making his own and letting friends and family taste them. At that time, he says, folks that were selling them on the streets got five cents for one tamale and six cents for a dozen.

Hicks got his tamale recipe from Acy Ware, who sold his hot tamales from a cart on the streets of Clarksdale. And the recipe remains a secret. It isn't written down anywhere. Hicks said he thinks his son knows the recipe.

"It's a lot of work to do tamales," Hicks said. "But there is something special when a person tastes a tamale for the first time and they like it. Money can't buy that."

He is particular about the ingredients he puts in his tamales. Some of the spices he uses are no longer available in the grocery store, so he must special order them, which, he says, is expensive. But those spices pay off, giving his tamales, which can be purchased in bundles of three, six, nine or a dozen, a nice peppery taste.

A specially made board holds the hots upright, making them easier for tying. *Author's collection.*

And to add a little extra kick to the joint, the restaurant is located in the old city jail. There are jail cells still in the back of the building, and Hicks will be glad to show you if you ask.

While his business, which also offers a vast menu of hamburgers, barbecue and other sandwiches, has done well over the years, seventy-two-year-old Hicks and his wife, Betty, are ready to retire. But they cannot find anyone who is willing to take it over.

"My son doesn't want to come back here," Hicks said. "If we don't find someone, we will end up closing." And that could mean no more Hicks hot tamales.

Betty Hicks said folks like their hot tamales. But when they find out how much work is involved in making them, they don't want any part of it.

As the Hickses search for a buyer of their business, Betty Hicks says the hot tamale recipe would be part of the sell: "You buy the restaurant, you get the recipe."

White Front Café

Barbara Pope, Rosedale

A little farther down the Mississippi River is a woman who is carrying on her family tradition. Barbara Pope continues to make the hot tamales made famous by her late brother, Joe Pope, at Joe's White Front Café.

Hot tamales and the blues converge outside Barbara Pope's White Front Café in Rosedale, where the first Mississippi Blues Trail Marker to feature food is located. *Author's collection.*

Barbara said her brother got his recipe from John Hooks, who also sold hot tamales. The story goes that Hooks got it from a Mexican migrant worker in the 1930s. Joe Pope changed the recipe a bit and began to sell tamales to earn some extra money. After a while, his side business became full time, and he opened his hot tamale trade in the white clapboard building in downtown Rosedale, where it remains today.

Barbara, the youngest of ten children, says she has changed the recipe only slightly from the one used by her brother, who was the eldest. According to the Southern Foodways Alliance, Joe Pope embodied the history of hot tamales in the Mississippi Delta. According to his sister, he barely fixed his breakfast, but he loved making the tamales.

Pope's cousin John Williams Jr. had fond memories of eating cousin Joe's hot tamales. In 1999, he opened his own hot tamale place in Cleveland: John's Homestyle Hot Tamales.

"When my brother was in the hospital, a week before he died, he asked me if I knew the recipe," Barbara said. "I told him I didn't. So sitting in that hospital room, he told me. I never wrote it down, but my sister did."

When Joe died in 2004 at the age of eighty, he had been making hot tamales for about thirty years, and he had established a reputation in Rosedale for making very good ones. Barbara took over the business in 2004. But she doesn't know who is going to pick up the mantle when she retires. Joe's grandson in Chicago can make them and so can her sister, but right now, neither are interested in the famous business. But the business must be passed on to a family member. That is the way Joe arranged it before his death. Barbara says there are family members interested in continuing the tradition of the White Front Café, but it's not clear yet exactly who it will be.

Blues visitors from around the world have found their way to Joe's White Front Café. Traffic at the café has increased in the past ten to fifteen years, thanks in part to European visitors traveling through the Delta. The Mississippi Blues Trail has even placed a marker near the front of the building commemorating the shared history of the Delta blues and hot tamales. It was the first marker on the Blues Trail dedicated to food.

Barbara makes 120 to 130 dozen tamales at a time. It is a two-day process that is time consuming. The first day is spent cooking the brisket she uses for the filling. On the second day, the tamales are rolled out and tied. She has one lady who helps her part time on the day the tamales are assembled.

Barbara puts her tamales together completely by hand; no machine has ever been used. A corn shuck is put down, and going by feel, she knows how much cornmeal to pick up and place on the shuck. The same goes for the

meat, which is placed on top of the cornmeal. The entire thing is then rolled up, causing the meat and cornmeal to spread out. During the winter months, she will make around 400 dozen a week and drop back to about 130 during the summer. More hot tamales are consumed in the winter than during the summer because of the warm spices associated with the food. She also keeps some in the freezer for folks passing through who may not be able to get back to see her for a while.

"We've done it this way for so long there is no need to change," Barbara said. "My customers expect that tradition to continue." Some of those customers have been visiting the White Front for years, some from as far away as Jackson and Memphis. When Joe first went into business, he charged $2.00 for a dozen tamales. Then, for a number of years, Joe, and then Barbara, charged $5.00 for a dozen tamales. Now she charges $10.00 for a dozen, $5.00 for a half dozen and $2.50 for a bunch (which is three tamales.)

When asked why she thought hot tamales were so popular, Barbara said, "It still amazes me why people like them so much. I think we take it for granted just how much people enjoy them. There is something special about hot tamales."

Over the years, a number of folks have made valiant attempts to duplicate Pope's recipe. According to the oral history of the Mississippi Delta Hot Tamale Trail, some people have paid big money for obtaining the recipe but stopped short of making them when they realized just how much work went into producing the tamales.

Pope, along with his hot tamales, is considered a major influence on the hot tamale industry in the Mississippi Delta and beyond.

"He inspired others to make and serve tamales," said Evans. "Joe Pope was a real treasure to the Delta and to hot tamales."

AIRPORT GROCERY

Jonathan Vance, Cleveland

Jonathan Vance grew up eating Doe's hot tamales from Greenville. In 1992, he bought Airport Grocery in Cleveland and wanted to serve hot tamales to his customers. So he had Joe Pope supply the eatery with tamales.

But when Pope became ill, Vance decided it was time for him to learn how to make this Delta delicacy. He turned to Pope to learn the ropes.

Recipes are closely guarded when it comes to hot tamales. Some are even taken to the grave. *Author's collection.*

Vance's family was from Benoit, and Jonathan's father, Cecil, was a close friend of Pope's—close enough that Pope shared his famous tamale recipe with Cecil and Jonathan. He took Cecil under his wing and showed him the process of making the tamales. It wasn't long before the father and son were making hot tamales and selling them to customers at the restaurant.

Over the years, the recipe Pope gave Cecil has been adjusted slightly. And only a handful of people know the recipe in addition to Jonathan (his father passed away in 2010). They include Meg McGee, general manager of the restaurant; a few family members; and Earnest Veale, a restaurant employee.

"We've had very little turnover of the folks who work with the meal and meat," Meg said. "So we've been able to keep the recipe guarded."

Meg said that she and Jonathan, while busy with the day-to-day operation of Airport Grocery, will take time to make hot tamales themselves occasionally. "Every so often, I say it's time to refresh so we don't forget what to do."

Meg says she enjoys making the tamales, and so does Jonathon; they just don't get to do it as often as they would like.

"I like cooking anything, but the hot tamale process is very relaxing," Meg said. "I like working with my hands. Making tamales is therapeutic, creative, an art form."

Delta Hot Tamales

They serve so many hot tamales at Airport Grocery during any given week (about 1,900 dozen, or 23,000 individual tamales, in 2015) that they are mixing or rolling hot tamales five days a week. Meg said the preferred way to eat them at the restaurant is plain, but they also offer them with chili and shredded cheese. She added that when folks come in who have never seen a hot tamale, she explains to them what it is along with some local history.

Meg said there is an allure to the hot tamale that those of us who are very familiar with it and grew up on it may not see. But young people and folks not originally from the Delta get a big kick out of their food being wrapped in corn shucks. Some folks think it's really cool.

"For me, the hot tamale is nostalgic. I've shared a lot of family traditions around a plate of hot tamales, especially at my grandmother's large dining room table."

Like most Delta kids, Meg grew up eating hot tamales, but unlike most families, hers also made them. Her father and three aunts know how to make tamales, and from time to time, they all get together and whip up a batch. One aunt lives in Oklahoma, and she enjoys making the hot tamales to share with friends, introducing them to the wonderful taste of a Delta hot tamale.

When Meg was living in South Carolina with her then husband, she would have hot tamales shipped to Cape Cod for family Christmas Eve dinners. She says they have shipped tamales from New York to Los Angeles and every place in between.

While she won't share the recipe, Meg did divulge a few ingredients that are common to most hot tamales. White cornmeal is used for the casing, and fresh certified Angus ground beef is used for the meat mixture. She said she felt like the type of meat used did a lot for the flavor, quality and consistency of their hot tamales.

Meg said she also has to explain from time to time that the word *hot* in the hot tamale does not mean it's loaded with hot peppers. She said she tries to explain it by saying it's the kind of hot equal to how a woman can be referred to as hot, as in sexy or attractive. She said their tamales are not hot, even though they have chili powder and maybe some Cayenne pepper mixed in.

Airport Grocery uses an extruder to help form the tamale; then the hands take over from there. Meg said she and the other tamale makers do not season the water when the tamales are steamed but instead season the meat and the meal mixture. They also use corn shucks because it adds flavor. Meg adds that the shucks also help hold in all the important stuff when the tamales are simmered.

"Tamales are just another [thing] that makes the Delta so special. And besides, where else on earth are you going to find them?" Meg said you can tell a lot about the person who makes the hot tamales.

"You have to trust people who make tamales. That tells you something about their character right there."

Juke Joint Food

Mark Azlin, Oxford

Delta born and raised, Mark Azlin started out farming before owning a popular restaurant where he made hot tamale history. He is the man responsible for the fried hot tamale. "Yep, that is me. I did it."

In 1998, Azlin bought an old general store dating back to the 1920s in Tribett, Mississippi, a small unincorported town in Washington County about eight miles southeast of Leland. If you didn't know how to get there, you would need directions. But out in the middle of almost nowhere, Azlin opened the Bourbon Mall. Steaks, seafood, music and good times in the country was all he was after.

It wasn't long before customers began asking for hot tamales. For a couple years, another Delta hot tamale maker supplied the requested treat for the Bourbon Mall. Then Azlin decided it was time for him to learn how to make them for himself. He didn't have to look far for a teacher. Veronica Ortega, a Mexican woman who worked at the restaurant, taught him the art of making hot tamales. Considering most folks think the Delta hot tamale was brought here by Mexican migrant workers in the early 1900s, this was like getting back to the root of things.

"She showed me their version, and I put my spin on it," Azlin said. "The main difference was she used masa and I used cornmeal. And I added more spice."

The most surprising thing Azlin learned from Ortega is that tamales are made with lard. No wonder they are so loved! Apparently, the lard holds the flavor of the seasonings better. Some hot tamale makers use shortening, but the lard is still out there in plenty of recipes.

The hot tamales were a huge hit at Bourbon Mall, but one night, fate stepped in and took this beloved Delta cuisine to a place it hadn't been before: the deep fryer. It seems that a couple cooks in the Bourbon Mall kitchen were

discussing hot tamales one night and wondered how they would taste if they were removed from the shuck, battered and dropped in some hot grease. Considering how much Deltans love their hot tamales and southeners as a whole like anything fried, it's surprising this concept hadn't been thought of before. A few customers were allowed to give the new creation a taste test. They must have liked it because more and more people began to ask for the deep-fried tamales.

"I didn't think much of it at first, but customers kept coming in the door asking for it over and over," Azlin recalled. "Then others began asking for it. I figure maybe there might be something to this."

It wasn't long before they were added to the menu. They became a favorite, selling as many of the fried hot tamales with a side of ranch dressing as regular hots. "This was just an experiment in the kitchen, but at the end of the day, customers loved it. We were the first to do this."

Azlin developed a beer batter for the frying process and, through trial and error, quickly found out a frozen hot tamale must be used. He said a hot tamale taken out of a warm pan of juice, shucked and battered just didn't work; it was kind of a mess.

The tamales, both fried and regular, were part of a crowd-pleasing menu until Bourbon Mall burned down one night in October 2009. The building was a total loss, but it wasn't the end of Azlin's tamales. Once again, he was about to take Delta hot tamales someplace new: the food service industry.

After the fire, he saw an opportunity to take his tamales, along with the salad dressing served at Bourbon Mall, and have them mass produced and sold to restaurants. Juke Joint Foods was born. The tamales are produced at an FDA-approved facility using his seasonings. Food service companies, such as Sysco, U.S. Food Service, Merchants Company and PFG, sell Juke Joint Hot Tamales to restaurants in Mississippi, Louisiana, Alabama, Tennessee and Arkansas that normally haven't served this Delta favorite. A few grocery stores in Mississippi also carry Azlin's hot tamales. "In the food service world, hot tamales are a niche item," Azlin said. "Every single hot tamale has to be hand rolled. There is no machine that can duplicate that. That makes tamales special."

Azlin doesn't have a lot of competition selling tamales wholesale or retail. "I'm proud to say we've got a good Delta recipe in the tamale world."

The fried hot tamale is not part of Juke Joint's offerings, but the hot tamales are sold with instructions on how to fry them if the customers want to try. There is one place to get the original fried hot: in Starkville at Azlin's hot tamale stand.

In August 2015, Juke Joint Tamale Company opened in this SEC Bulldog-loving town. Reminiscent of an old juke joint, it is the only hot tamale stand around and is rather busy on home football game weekends for Mississippi State University. In addition to regular hot tamales, the original deep-fried hot tamale is offered.

Azlin said sometimes he has to give instructions on how to eat them because some folks think the shuck is part of the meal. Or he may have to explain what is in a hot tamale. "A lot of times, if someone is a hot tamale newbie, I'll suggest they try the fried hot tamale first. No instructions required on how to eat it."

Azlin, a native of Leland, Mississippi, grew up eating tamales from Etta's Hot Tamale stand in his hometown. He has fond memories of his dad pulling up to the window at her house and ordering hot tamales, which would be wrapped in newspaper.

"Daddy would also say he didn't see a cat in the neighborhood, but we would eat them anyway." For years, there was a running joke that tamales might have been made from cats. This came about because no one knew exactly what was in a tamale. We know better now.

But his love for tamales has only grown over the years, although he never imagined they would be his livelihood. He never thought the fried hot tamale would be such a big hit either.

"I was dumbfounded, but when folks tell you they drove an hour and a half just to eat fried hot tamales, you know you are on to something," he recalled. "I had a three-pound porterhouse steak with a crawfish sauce, but folks wanted the fried hot tamale."

Other restaurants serve the fried hot tamale, but Azlin is proud that he was able to introduce it to tamale lovers. And with Juke Joint Foods, he is introducing Delta hot tamales to a whole new world.

JEFFERSON'S HOT TAMALE

Gerald Jefferson, Greenville

Tamales have been a part of the Jefferson family for decades. Their father got the recipe while in Mexico and gave it to their mother to make the tamales. As young men, Gerald, William and George Jefferson would take their mother's homemade hot tamales and sell them out

Gerald Jefferson begins the process of hand rolling tamales, the most labor-intensive part of making this Delta delicacy. *Author's collection.*

of a pushcart. William recalled pushing the cart through downtown Greenville, dubbed the Hot Tamale Capital of the World, and yelling, "Red hots, molly man!"

While all three know how to make them, Gerald is the primary tamale maker now.

"We've changed up the recipe some from the way Mama fixed them," the youngest brother, Gerald, said. "I'll tell you this much, it's the garlic in both the brisket mixture and the cornmeal mixture [that's the secret]."

The tamales are sold out of his home. Folks call up, place orders and pick them up. And they are already planning to pass them along to the next generation. Gerald is teaching his sixteen-year-old son how to make hot tamales. "He's almost got it down pat."

Gerald says one reason his tamales taste so good is the juice they simmer in. "The juice is seasoned as well, and I let them simmer for a while," he said. "It just adds to the flavor."

While every tamale maker's recipe may be different and a well-guarded secret, all agree on one thing: there are numerous ways to eat hot tamales.

Eugene Hicks likes to serve his with his homemade chili. William Jefferson prefers saltine crackers and ketchup, and George Jefferson wants chili, ketchup and cheese with his. Hot sauce is also a favorite condiment with tamales, and a few even like lemon juice.

"There is no right way or wrong way to eat a hot tamale," Gerald Jefferson said. "Just enjoy eating them."

DOE'S EAT PLACE

Signa Family, Greenville

One of the most iconic places in the Delta where hot tamales have been on the unwritten menu since day one is Doe's Eat Place in Greenville. Pulling up to the white clapboard building on Nelson Street could give pause to going in. Walking in on worn hardwood floors to walls covered in photographs of the famous and infamous, you get the feeling that something wonderful might have happened here. And it did. It was here that Dominick "Doe" Signa helped to introduce the area to hot tamales.

Doe's father had moved to Greenville in 1903 and opened a grocery store in the building where the restaurant is currently located. The family lived in a house behind the store. The grocery store did well until the 1927 flood hit the area, sending water from the swollen Mississippi River racing through the community.

To help the family get back on their feet, Big Doe, as he was known, got into bootlegging. After several years, he sold his forty-barrel still for $300 and a Model T Ford. In about 1941, Big Doe got his hands on a partial hot tamale recipe from a co-worker at the Air Base in Greenville. He gave it to his wife, Mamie. She worked on improving the recipe, and it wasn't long before the couple was selling hot tamales. And that was the beginning of Doe's.

And the rest of the family jumped right in to help. Son Charles Signa says his mama's sister and his daddy's sister started rolling and tying the tamales. His grandfather ran a honky-tonk in the front part of the store strictly for black customers. He was serving items such as buffalo fish and chili. White customers entered through a side door. Hot tamales were available to both white and black customers. As business began to pick up in the back of the store and he began preparing steaks, Big Doe called in the family to help, and the honky-tonk eventually was shut down as the focus was turned to the restaurant.

Some credit the late Dominick "Doe" Signa with introducing hot tamales to white customers in Greenville. His family continues the tradition at Doe's Eat Place. *Author's collection.*

The hot tamales were a signature item long before the now famous Doe's steak. "Hot tamales were a way for Daddy and Mama to make a living," son Doe Jr. said. "And it worked."

Family matriarch ninety-year-old Florence Signa is a member of the first generation of the family still involved in the business. Known to everyone as Aunt Florence, she was married to Big Doe's brother Jughead.

"If someone can make a living making hot tamales, then I'll try it myself," she said, speculating on why Mamie and Big Doe decided to give hot tamales a try.

Mamie and Doe tweaked the recipe until they were happy with the results. Whatever they came up with in 1941 is still being used today. The tamale recipe has never changed, nor has Mamie's salad dressing, which is still used in the restaurant today.

For years, the hot tamales were made entirely by hand. Then Big Doe purchased a tamale-making machine to help streamline the operation. And as soon as sons Charles and Doe were out of college, they were working at the restaurant and helping to make the tamales with a closely guarded recipe behind closed doors.

The brothers aren't as secretive and closed door about the process now, but they closely guard the hot tamale recipe. Charles said there

is no secret ingredient, but the amount they use to get the seasonings just right is proprietary.

"I've been working here for sixty-nine years, and I can't tell you what's in the tamales," Florence said. "And people ask me that question all the time."

Today, Little Doe, Charles and their sons know the recipe, and one of them will mix up the seasonings. All of the hot tamale making now takes place in broad daylight and without closed doors. Restaurant employees assist with the rolling and operating the tamale-making machine. During most of the year, they will make tamales once a week, but during the Thanksgiving and Christmas holidays, they kick it into high gear and will make them as often as needed to keep up with the demand for both the dine-in customers and the carryout orders.

When Big Doe and Mamie first started making the hot tamales, they used corn shucks. They originally got them from an area farmer. Later, they obtained them from a company in Texas that got them from Mexico.

"Daddy heard they were sneaking marijuana in the corn shucks from Mexico, so he stopped using shucks," Charles recalled. "That's when we began to use parchment paper wrappers. And they are cheaper." By using the paper, you eliminate a time-consuming step, even though the shucks give the hot tamales a different flavor.

For many years, if folks wanted hot tamales to take home, they would bring their big pots to the restaurant and have them filled with the requested number. Then coffee cans were used to transport tamales for to-go orders. Eventually, the health department said they couldn't do that, so now plastic containers are used to transport the hots home.

Florence said she has seen all kinds of reactions when folks eat hot tamales for the very first time.

"Sometimes, we have to show them how to eat a tamale," Florence said. "They want to eat the shuck. But once they take a bite, they are saying, 'Oh, my goodness, that is so good!'"

Most customers prefer the hot tamales with nothing or with saltine crackers and some ketchup for dipping. But they do have one customer who requests mustard. Hot sauce and lemon juice are also condiments used to dress the tamales. They have even witnessed customers who will crumble their tamales onto their salads and smother it with chili and cheese or dip a bit of tamale in the juice from a grilled steak. This just reinforces the theory that there is no wrong way to eat a hot tamale.

Doe's has certainly made its place in hot tamale history in the middle of a community that has more hot tamale makers than anyone else, a trend that has gone mostly unexplained.

"I don't know why there are folks who make hot tamales in Greenville or why you have so many blacks making them," Charles pondered. "Only thing I can think of is maybe it's a way to make money."

And just like their daddy did all those years ago, Charles and little Doe and their sons are carrying on the tradition of making hot tamales.

DELTA FAST FOOD

Gentle Lee Rainey, Cleveland

Gentle Lee Rainey didn't have to go looking for hot tamales. They came to him. He comes from a long line of hot tamale makers. His grandfather made hot tamales, and Rainey has been making them since 1995 to sell at his store, Delta Fast Food in Cleveland.

When you walk into Rainey's business, your senses are immediately put on high alert as you scan the shelves loaded with candies and snack items. A couple tables are off to the side for those who want to sit a spell or even enjoy something off the extensive menu board: hamburgers any way you like them, hot wings, gizzards and livers or a cold-cut sandwich are just a few of your options. And there, right in the middle of the menu, are the hot tamales. A half dozen will cost you $5.99 and a dozen, $9.75.

Rainey raises the countertop and steps into a backroom, just out of sight. The aroma precedes him as he makes his way back to the front of the store. He appears holding a Styrofoam container displaying a dozen handmade hot tamales. If they taste anything like they smell, that plate of hots won't last long.

"I've had Delta Fast Food for about twenty-one years, and I've always had hot tamales here," Rainey said. "I've always been around them, so I had to have them here."

His grandfather sold hot tamales in Ruleville in the 1960s and '70s to make a little extra money, a common scenario. Why or how hot tamales made their appearance in the Mississippi Delta are not great concerns to Rainey. "I just know folks like them. They are part of the Delta."

Rainey was born on Dockery Plantation, where his grandfather made hot tamales using corn shucks from fields there on the farm. It was there that he and his entire family learned to make tamales. Located just east of Cleveland, Dockery was established in 1895 by Will Dockery for harvesting timber and

growing and ginning cotton. The Dockerys also owned thousands of head of cattle. At one point, the farm boasted ten thousand acres. A progressive farm for its time, Dockery's rightful place in history was forever sealed when blues legends Charlie Patton and Howlin' Wolf called it home for a period of time in the early 1900s. Many, including B.B. King, consider Dockery the birthplace of the blues. While there is nothing to substantiate this, you can't help but wonder if these two men had a few meals of hot tamales. As history would prove, both the men and the tamales became a part of the Delta fabric and have helped to carry the Delta's story around the world.

Charlie Patton, Howlin' Wolf and hot tamales—you can't get much more Delta than that.

To this day, Rainey continues to make his hots entirely by hand using the recipe he learned from his grandfather. The only thing he has changed is adding a little more seasoning, which he says is what makes them so good. Exactly what those seasonings are is a secret, but he will say he uses only the best. He also will not disclose what kind of meat he uses. That's a secret, too.

"I have tried all different kinds of meat: beef, chicken, turkey. Depends on what holds the seasonings the best," he said. "They have a nice mild flavor. They are not hot, hot."

He has even tried frying them but decided that was just too much work for him, so he sticks with the traditional tamale.

Rainey makes from twenty to thirty dozen hot tamales a week or more if he needs them. Since his store opens at nine o'clock in the morning and doesn't close until nine or ten o'clock at night during the week and midnight on the weekends, the hot tamale–making process doesn't happen until the early hours of the morning. He comes back to the store about midnight during the middle of the week to make and roll the tamales. It's the only time he says he can get it done so the process doesn't interfere with the store. He does have someone who helps him with rolling the tamales.

Every once in a while, someone comes in who has never had a hot tamale before, usually someone from out of state, and he has to show them the proper way to eat one.

"I've even had folks ask if the tamales are in the shuck or the can. I just laugh." He goes on to say that folks from all over the country stop in. Most eat hot tamales plain, sometimes accompanied by crackers or with chili. Rainey said he has one customer who insists on eating his tamales cold right out of the refrigerator. He doesn't care how they are consumed, he is just happy folks buy them, saying once folks try his hot tamales, they always come back for more.

But he doesn't touch them much anymore. After years of eating and making this Delta delicacy, he is burned out, saying he personally doesn't like hot tamales anymore. Now he only tastes them to be sure the flavor is perfect.

Apparently, he is hitting his mark. While I was interviewing him, a customer walked in to order hot tamales and went on and on about how good they are, calling them delicious.

"My old family recipe makes them good," Rainey said. "They are quick [to eat], they are good and they fill you up."

Rainey and his brother know the hot tamale recipe. It's not written down anywhere; it's all in their heads. And while he's not sure to whom he'll pass on the recipe, he hopes his generations-old recipe is carried on for future tamale lovers.

HOT TAMALE HEAVEN

Harmon Family, Greenville

Willie Harmon got into the hot tamale business on the advice of his father, who told him when he was a young boy to never work for someone else all your life. That advice stuck with him. Once he was out of high school, it didn't take too many years before he was on his own making the Delta's most beloved food.

He ran a juke joint for a while called the High Stepper. His brother-in-law told him a bail bondsman said if a man goes to a town where there are no hot tamales, that man could make a living. Turns out a woman Harmon knew from the juke house knew a lady in Lake Village, Arkansas, who could show him how to make hot tamales.

Evelyn Webb was the lady who introduced him to hot tamale making. She showed him how to make them but never gave him a recipe. He paid close attention as she added, without measuring, spices and seasonings to the meat mixture.

"I went home and started practicing, and it didn't take me too long to get pretty good at it," Harmon said. "I knew I had something."

Once he had the recipe down, he quickly got to work. One Saturday while his wife was at work, he decided to make some hot tamales to sell. He made the tamales and called a few folks to let them know he had some available. The friends came over and bought him out.

"I made five or six dollars that day," the seventy-one-year-old Harmon recalled. "I was so happy you would have thought I [had] made a million dollars!"

When his wife, Inez, came in from work, he shared his good fortune with her. He said she was so excited she wanted to see the money. The Harmons' hot tamale business was born. "We immediately began peddling our hot tamales out of the trunk of my wife's car."

"My wife said if I would get her a cart, she would go set up in front of Stein Mart Department Store and sell hot tamales," Harmon said. "I got her a cart."

As a matter of fact, the Harmons' first hot tamale cart came from another legendary Delta hot tamale family, the Scotts of Metcalfe. Harmon bought an old wooden cart from Aaron Scott and gave it a new coat of paint and new wheels. They were ready to get out and sell their handmade hot tamales.

Inez hit the street on Friday and sold thirty dozen hot tamales at three dollars each. The next day, she sold sixty dozen. The ideas were rolling through Harmon's head as fast as the wheels were rolling on the cart down the street. If one cart could do that well in two days, how much money could he make with two carts on the streets?

"I brought my wife in off the cart. I got my brother-in-law and another cart," Harmon said. "We set up in from of Kmart and the Mainstream Mall."

While the men were out manning the carts, Inez was home making hot tamales. She would take the men more tamales if they ran out. The entire family got involved with the tamale business. All six of their kids helped make the tamales. And over the years, Harmon taught them the recipe and had them commit it to memory, though one copy is written down and locked away in a safe.

But he had to have a name for his new business. Son Aaron gets that credit when, as a young boy, he came up with Hot Tamale Heaven.

They eventually opened a stand on Theobald Street in Greenville, where they stayed busy. In 2007, they moved to a new, high-traffic location on U.S. Highway 82.

But the entire time Harmon was growing his retail business, he was working on plans to wholesale his tamales as well. And he already had the building to use for making tamales in mass quantities. He had purchased the old Pepsi Cola Bottling plant in downtown Greenville in 2006. He originally bought it for the young men in the community, to give them a place to go, something to do. But it was perfect for a USDA-approved plant to make his tamales. They make about two thousand tamales in eight hours.

Harmon and his sons—Aaron, Sam and Lou—began taking hot tamales to the next level in Greenville. Hot Tamale Heaven is the first tamale producer in Greenville to wholesale its product.

"It's doing great but we want to take it further," Harmon said. Harmon doesn't like to discuss intimate details of his business, like how big the area where he wholesales his tamales is. But he says it is going good and that he wants to expand. He wants to get Delta hot tamales, his hot tamales, into more restaurants and businesses. Several restaurants throughout the Delta get their tamales from the Harmons but create their own seasoning.

And because some of his customers are outside the hot tamale bed in the Delta, he has to show them how to eat a tamale and explain exactly what is in this treat. "I take a pot of hot tamales with me when I call on someone who doesn't know what they are."

Harmon says one thing has remained important to him from day one: making sure his tamales taste good. He said his main concern wasn't how much it costs to make them but whether people enjoy them. "I wouldn't make a tamale I wouldn't serve to my mama," he said.

Aaron and his brothers, Sam and Lou, all work in the family business. Each one oversees a particular area of the company. They have been involved since they were little boys. Aaron said he started helping with the tamales when he was six or seven years old.

"Sometimes, we weren't too happy about helping, but we did it," Aaron said. "Our parents had us rolling and making tamales."

And then there were the days their dad would get them out of school because he needed help making the hot tamales. Harmon said when the kids first started working, he could pay them with a package of cookies, a gallon of milk and some ice cream and they were happy. But when they got older, they wanted money.

As his sons got older, they followed in Harmon's footsteps, peddling the hot tamales. They had a couple trucks and would take off to the smaller communities to sell the tamales. The senior Harmon added that he loved peddling and would go back to it if he could.

Aaron handles the retail side of the business, but he wasn't always sure this was going to be where he ended up even though when he came home on the weekends from school at Mississippi Valley State University, he lent a hand to the tamale-making process. He was majoring to become an environmentalist because it sounded good, but his heart was not in it like it was in tamales.

Today, he is helping his family grow their business. With thirteen employees, they see hot tamales taking off in areas beyond the Mississippi Delta.

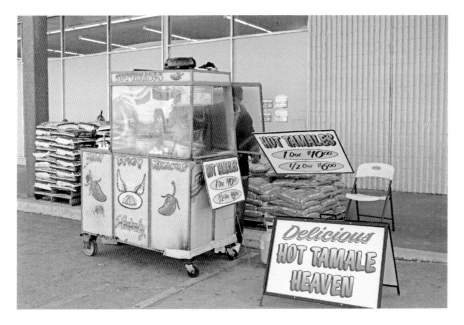

Hot Tamale Heaven in Greenville is one of only two tamale vendors that still use a push cart. *Author's collection.*

When asked how the hot tamale ended up in the Delta in the first place, Aaron speculates it was the Native Americans who lived in the area.

"The tamale kind of embodies the spirit of the culture here," Aaron added. "Mississippi Delta tamales go along with the blues. They're part of the black people's identity also in this area."

The elder Harmon added that back then (early to mid-1990s), black people had to find some kind of business to make a living. "Then they learned how to make hot tamales—lots of hot tamales," he said.

And Aaron feels every indigenous culture has its own version of a tamale, a food that can be wrapped in a corn shuck or a banana leaf, some sort of food that can go with you and travel easily.

The Harmons' hot tamales are traveling across the Delta and the state. They will share their tamales any day, just not their recipe.

"My hot tamale recipe is going to stay in the family," Harmon said. And with a smile he added, "It's our little family secret."

JENNY'S TWICE THE HEAT

Adrian Sutton, Hernando

Adrian Sutton loves hot tamales. She has been eating them for years. When she moved from the Mississippi Delta to the outskirts of Memphis in the community of Hernando, Mississippi, she couldn't find the tamales she loved and craved.

"I could find hot tamales in Memphis, but they were different; the texture was different," Sutton explained. "I wanted Delta tamales, and I didn't want to have to drive back to Greenville to get them."

And Sutton was curious. She wanted to know how they were made. She finally decided the only way she was ever going to get the kind of tamales she wanted was to make them herself. In 2014, Jenny's Twice the Heat Hot Tamales was born. Mildred Jerman of Millie's Hot Tamales in Greenville had won first place in the 2005 World Championship Hot Tamale Contest. She was also a friend of Sutton's and agreed to show her the ropes. The two ladies gathered in Sutton's kitchen, and the lessons began. But like with all good hot tamale recipes, not all was revealed. "She showed me some of what to do. I had to figure the rest out for myself. So I searched the Internet to fill in what I didn't know," Sutton said.

Getting the seasonings just right was the hardest part for Sutton. There was a lot of trial and error before landing on the perfect combination. She seasons both the meat and the masa for her tamales and uses turkey or ground beef. She also makes a pinto bean veggie tamale.

"It took me a little while, but I finally have a recipe I am happy with," Sutton said. "And I think the folks who buy my hot tamales like it, too, or they wouldn't come back!"

When she first began making her hots, Sutton prepared them only on request. Now she takes orders or makes several dozen for the weekend and often sells out. She makes them every week or two, about sixty dozen at a time. Sutton uses a machine to create her tamales, although she started out with a completely handmade process.

"The tamale I make is more like a true Delta tamale, which is much better than the tamales I've found up here," she said.

While she is relatively new to the hot tamale business, Sutton says she hopes to keep the tradition of Delta hot tamales alive. "I'm ready to take the hot tamales on the road. Time to introduce them to some other folks who don't know what they are missing."

WORLD CHAMPIONSHIP HOT TAMALE CONTEST

Frank Carlton, Greenville

Frank Carlton loved hot tamales. And he recognized that Greenville loved them, too. He even dubbed Greenville the hub for hot tamales. The lawyer, former district attorney and hot tamale aficionado told the *Delta Democrat Times* in 2008 that it is essential in the tamale trade to think your tamales are the best.

"If you don't think you're making the best hot tamale in the world, you best not be making them at all," Carlton said. "I think everybody thinks theirs is the best."

So how is the best hot tamale in the Delta decided? With a contest, of course. Carlton loved hot tamales so much that he began the World Championship Hot Tamale Contest in 1990 in conjunction with a food festival hosted by the Warren Washington Issaquena Sharkey Community Action Agency (WWISCAA) in Greenville. Each entrant's hot tamales were judged on flavor, appearance, texture and overall impression. For fifteen years, hot tamale makers from throughout the Delta and across the state came to Greenville for the event. Contestants like Shine Thornton and George Dailey entered every year.

The hot tamale contest was bankrolled completely by Carlton. He awarded trophies and money to the first-, second-, third- and fourth-place finishers. Every entrant went home with something. And of course, the winners got bragging rights. Each year, the number of contestants ranged from ten to fifteen. The final festival was in 2005. Carlton said the event had gotten too big for him to continue footing the bill alone.

But it was the tamale contest that inspired Carlton to learn how to make them himself. He bought two hot tamale–making machines and began experimenting. He made up his own recipe

The late Frank Carlton is the founder of the original hot tamale–cooking contest, which ran for fifteen years. *Amy C. Evans.*

and called on his friends to help him make them. He was a member of the Big River Goat Ranch Big Ass Cooking team, which cooked and catered for various events. The group would make about two hundred dozen tamales at a time. He sold them for six dollars a dozen out of his downtown law office.

His tamales were a little bigger than the usual Delta size. They were made with potato, zucchini and an olive. They were also spicier than the average tamale. He never entered the contest, saying it just wasn't appropriate to have his tamales in the championship. But he had an opinion on where he might finish if he had entered: "Mine are the best, of course!"

Carlton even claimed to know the secret to a good tamale: chili. He said, "If you can make chili you can make hot tamales."

Carlton died suddenly in March 2009. His passion for hot tamales is recognized still with the Frank Carlton Hot Tamale Cooking Contest, part of the Delta Hot Tamale Festival in Greenville. Carlton made hot tamales fun because he was fun.

SCOTT'S HOT TAMALES

Scott Family, Greenville

The Scotts are considered the first family of hot tamales in the Mississippi Delta. Theirs is a love story that began in 1941. Aaron and Elizabeth Scott built a family together, raised nine children and started a business that has become part of the fabric of the hot tamale industry.

It all started with the cravings Elizabeth had while pregnant. She wanted hot tamales. She was eating them all the time—couldn't get enough of them. Her husband was constantly bringing them home.

Then one day, he said enough. He went out and found a hot tamale recipe and decided to try his hand at making them.

The young married couple was living in San Antonio, Texas, at the time. Aaron was stationed there with the U.S. Army. He bought a hot tamale recipe from a Mexican he met there. It's not known how much he paid for the recipe, but it's probably safe to say it has more than paid for itself a few times over. The couple began making hot tamales, perfecting the recipe and making it their own.

A couple other people were making hot tamales in Greenville when the Scotts moved back to the Delta. Tamales cost twenty cents a dozen at the

The late Elizabeth Scott (right), matriarch of the Scott hot tamale family, works beside her family on tamale-making day in 1999. *Scott family.*

time. They obtained a hot tamale cart soon after arriving, allowing them to peddle their tamales downtown. They also sold hot tamales in small Delta towns of Benoit, Scott and Shaw.

The couple began selling hots from a cart, which some have said was one of the finest in the Delta. A hot tamale stand followed on Nelson Street. As the demand for their hots increased, the Scotts moved their stand to Mississippi Highway 1.

As the kids grew, they, too, learned the finer points of making the perfect hot tamale, how to operate the extruder, how to tie the bundles and clean the shucks. It became a family-owned and operated business in the truest sense of the word.

In 2005, Elizabeth told Amy C. Evans, oral historian for the SFA, that when the kids came home from school, she would have ingredients ready and they would pitch in to help her finish them. She always liked tamales and remembered eating them as a teenager. She also remembered a couple people in Greenville selling them at that time. When she would go to the movie with friends, they would get some tamales, and she would always take some home.

The Scott family settled in Metcalfe, and the tamale making was on. In addition to the cart, they also had a station wagon, a dual way to get the tamales to the public.

Lorretta Gilliam (left) and Marie Benson (center) continue to help with the family business started by their father and mother, the late Elizabeth Scott (right), 1999. *Scott family.*

For many years, the tamales were made entirely by hand. Daughter Loretta Gilliam said she enjoyed making them without the use of the machine, which they bought in the 1970s.

"It was a lot of work, but it was fun," Loretta said "We used a fork to spread the meal and meat mixture onto the corn shuck."

The tamales produced by the Scott family are smaller than some when they come off the extruder. Only about two and a half to three inches long, their tamales are manually removed from the machine. Sister Hazel Brown mans the machine most weeks and said they have always made them small.

"It's a feel. You just know how long that tamale is supposed to be," Hazel said. "Besides, it's easier to handle this way."

Once the tamales cook, they expand inside the shucks and come out the perfect size.

Every week, at least five or six family members gather at their mother's home in Metcalfe to make the tamales. The production process takes place in a special kitchen added on to the Scott family home. In the middle of the room are big tables, giving the family plenty of room to form and cut tamales, roll them in corn shucks and tie them together. It's really an assembly line.

"Everyone here knows their job," Loretta said. "But if one of us is out, anyone in this room can fill in, if need be."

On Tuesday, the brisket is cooked and shredded and the meal mixture made. Both are then refrigerated so they will be easier to handle the next day. Then on Wednesday, the big work starts in earnest. The group will make and roll about one hundred dozen hot tamales to sell at the stand in Grenville.

And it's also family members who work at the tamale stand. They open at four thirty in the afternoon on Tuesday through Saturday and close at ten o'clock at night on Tuesday through Thursday. The stand stays open until midnight on Friday and Saturday. The sisters, along with grandchildren and nieces, are the primary ones who work the stand.

As the family is busy cleaning shucks, making tamales and rolling them in corn shucks, brother Herman told me that when they were kids he always wanted to be inside making tamales rather than outside. "We had a big garden and chickens and there was a lot to do out there. It was a whole lot more fun in here."

Over the years, they have made some specialty tamales, but the originals are their favorite.

"I didn't think we would ever end up making this many tamales," Elizabeth told Amy C. Evans. "Didn't think it would continue. Now it's up to the children."

Aaron Scott died in 1987. Elizabeth Scott passed away in 2016 at the age of ninety-three. She had retired from the tamale-making business in 2001 at the age of seventy-eight. Over the years, the accolades came, praising them for keeping this Delta tradition alive and well. They were written up in *Southern Living* and received trophies for tamale competitions, but the highest honor came when Elizabeth Scott was awarded the 2007 Ruth Fertel Keeper of the Flame Award by the Southern Foodways Alliance. In addition to a cash award, a short film entitled *Rolling Tamales on MLK* was produced that documented her six decades in the tamale business.

Brothers and sisters work side by side each week making tamales for Scott's Hot Tamales in Greenville. *Author's collection.*

Scott's Hot Tamales have held up for sixty years. So what makes them so special?

"The amounts of the seasonings," Loretta said. "And a lot of tender loving care."

All of the brothers and sisters agree their parents would be very proud of them for keeping up the family business. Sister Eunice Pennington said their daddy is probably looking down from heaven and saying, "Good job." "That's what carries me on," she said.

It was no surprise that this lively, fun bunch could offer some suggestions on how to eat hot tamales. Raymond likes to pull them out of the shuck and just eat them. Eunice prefers to dip them in cheese sauce. Sister Marie Benson, the fastest hot tamale string tier around, suggested trying them on a bed of rice.

Even though their parents are gone, the family agrees, hot tamales are something their mama and daddy just loved, saying their daddy was always just trying to please mama.

ONWARD STORE

Linda Agee, Head Cook, Onward

Onward, Mississippi, is important to Mississippi and national history. It's the location of the famous bear hunt by President Teddy Roosevelt when he refused to kill a bear tied to tree. The result of the president refusing to pull the trigger set off a cartoonist who coined the phrase "Teddy Bear." A toy company saw an opportunity, and the plush, cuddly toy was born.

Hot tamales are one of the main attractions at the Onward Store. They've been served there since the mid-1990s. While the store owners get the plain hot tamales before they have been simmered from Hot Tamale Heaven in Greenville, the cook adds a secret blend of seasonings.

"They won't tell me the recipe," James Henry Wilson said, laughing. "They refuse to tell me."

The tamales at the restaurant have a deep reddish-brown color, an indication of their rich, spicy flavor. Tourists have been stopping at the Onward Store for years, which, as its name suggests, was a store for a very long time before becoming a restaurant. It offers a variety of supplies and short-order food like burgers and hot tamales. And it

keeps an array of photographs and Teddy Bears pertaining to the Great Bear Hunt.

The store is a popular stop on the Mississippi Blues Trail, attracting folks from all over the world. "When I mention tamales, their faces just go blank," Wilson said. "When I explain [they are] beef in a corn shuck they think that is the stupidest thing they have ever heard of. But I tell them it's the best thing they will every try. Then they are hooked."

Linda Agee, the cook at the Onward Store, said they have been using the same recipe for the spices since she started working there in 1996. She doesn't know who developed the seasoning mix or when they began using it. So what makes it so special?

"It's a secret," Agee said. "And nobody else has it."

She and Wilson say they have loved hot tamales since they first tried them, and they both like to enjoy the hots with a side of sour cream and maybe some shredded cheddar cheese.

Sho Nuff Hot Tamales

Perry Gibson, Metcalfe

During the week, Perry Gibson drives a truck. But on Thursday, Friday and Saturday evenings, he is in front of Spanky's Barber Shop at the corner of Washington Avenue and Theobald Street in Greenville. You can't miss him. He is the one with the hot tamale cart. One of only two people in the Delta still using a push cart, Gibson likes the idea that he is keeping this tradition alive.

He grew up wanting to learn how to make hot tamales. He says he learned from a lady who used to be married to legendary hot tamale maker Joe Pope from Rosedale.

"I was friends with her son, and he knew I wanted to learn how to make hot tamales," Gibson said. "I learned all right. I learned how to make them completely by hand. And I was just fifteen years old."

Now forty-nine, he hasn't stopped making them. Gibson said when he first learned, some folks were using bread or cracker crumbs to make the meat go further. And tomato juice was used to make the juice for the tamales and help give them a reddish color.

The lady who taught Gibson tried to discourage him, saying tamale making was too much work. But he persisted, telling her he really did want

to know all about hot tamales. His mother even said she would help him make the tamales. But after a few times, because of the work involved, she told him that he needed to find someone else to assist.

"I knew I had a passion to make tamales," Gibson said. "This is what I wanted to do."

Over time, Gibson was able to purchase a tamale-making machine, which made the process move along quicker. By 2001, he was making hot tamales on a regular basis. But it was hard to break into the business when there were so many other good hot tamale makers around the Delta. He says he couldn't find out where to buy supplies because everyone was so secretive.

"My recipe is in my head. No one else knows it but someone will find a copy in my safe one day," Gibson said. Gibson worked hard to perfect his recipe, adjusting the seasonings until he was satisfied. He said it took him ten years to get it just right. He does use brisket as his meat and masa because he likes the finer texture.

In late 2009, Gibson began selling his tamales from a cart in downtown Greenville. He said people just gravitate to it because it's not something you see all the time. By going to the same street corner all these years, Gibson has made himself something of a mobile storefront. Folks know where to find him and what his cart looks like.

"I do very well selling out of the cart," Gibson said. "I've heard of people who used to push the carts up and down the streets. I like the idea of the cart but I just stay in one spot."

He says it's important to preserve these traditions before they are lost.

When Gibson first began selling tamales, he also had a snow cone hut. Folks would come by and say his hot tamales were "sho nuff" good. The compliment became the name of his business. He has made other varieties of tamales, including spinach and venison, but he prefers the good-old traditional tamale the best. He says he makes more money with the traditional tamales, and some of the specialty hots take too much time. But he thinks the specialty tamales are going to evolve, primarily the spinach tamale. But how does he like to eat his? He used to eat them with sandwich bread, making a very simple but filling meal.

Every week he makes between one hundred and two hundred hot tamales or more if they are needed. He has a friend who helps him out.

Gibson said he loves making hot tamales, that it's all he has ever done. And he can make a little money doing something he is truly passionate about.

"Greenville is a good testing ground for hot tamales. If you can make it in Greenville, you can make it anywhere."

Hot Tamale Chants

When the hot tamale vendor would push his cart down the street, he would call out a rhythmic chant to get everyone's attention, and hopefully, they would come out and buy a couple bundles of hots. This is an example of one such chant used by George Jefferson of Greenville when he would push his tamale cart: "Molly man! Red hots! Molly man!"

Willie Harmon still uses a chant but in a different setting. As a hot tamale wholesaler, he will chant to a new customer to give them the full effect of a Delta hot tamale:

> *The name of my business is Hot Tamale Heaven. I make the finest hot tamales in the Mississippi Delta. Have you ever seen a king before? Look at me! When it comes to hot tamales, look at the king, and I'm here to prove it.*
>
> *Anyone wish to buy, wants to buy, can buy.*
>
> *Now you tell your friends to tell their friends that the hot tamale man is in town*
>
> *And I ain't lying.*
>
> *Finger licking good, satisfaction guaranteed!*
>
> *If you try it, you'll love it!*
>
> *My hot tamales as good as huggin' and kissin'!*

Plates of hot tamales are ready to be served to contestants of the tamale-eating contest at the Delta Hot Tamale Festival. *Main Street Greenville.*

A tray of rolled tamales comes out of the freezer ready to be submerged into water and spices for simmering. *Author's collection.*

Eugene Hicks at Hicks World Famous Tamales and More developed a special board to hold hot tamales for tying. He says it saves time. *Author's collection.*

A bundle of hot tamales comes out of the pot of brownish-orange juice ready to be served at the White Front Café in Rosedale, Mississippi. *Author's collection.*

Above: Don't miss sopping up the juice of the hot tamales at Larry's in Clarksdale. *Author's collection.*

Right: With promises of home delivery, this sign is all that remains of an abandoned hot tamale stand on Mississippi Highway 444 in Duncan, Mississippi. *Author's collection.*

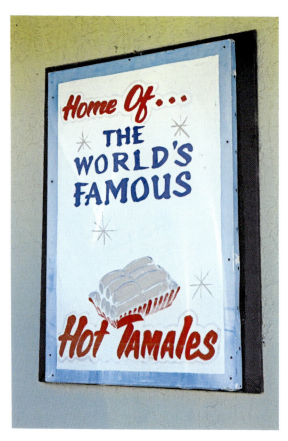

Left: Promises of the world's famous hot tamales greet guests at Hicks World Famous Tamales and More in Clarksdale, where he has been making tamales for fifty-five years. *Author's collection.*

Below: Hot tamales lined up on a tray wait to be wrapped in a corn shuck and simmered. *Author's collection.*

Above: Hot tamales can be served up plain or with a side of saltine crackers, ketchup or hot sauce. There is no wrong way to eat a hot tamale. *Author's collection.*

Right: Betty and Eugene Hicks are known for their hot tamales but are not sure what will happen to the secret recipe as they face retirement. *Author's collection.*

Deep-fried hot tamales can be found at various restaurants and hot tamale stands around the Delta, but they were invented by Mark Azlin at the Bourbon Mall. *Author's collection.*

Flaky pie crust paired with a hot tamale mixture that includes corn, olives and roasted tomatoes make this deep-fried hot tamale pie a special treat. *Author's collection.*

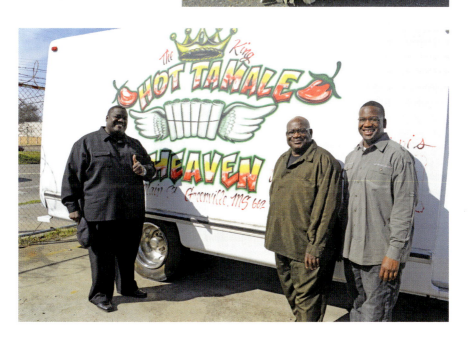

Right: Jade Mixon, wearing a gown covered in corn shucks, was crowned Miss Hot Tamale 2012 at the first Delta Hot Tamale Festival in Greenville. *Main Street Greenville.*

Below: The Harmons are the biggest supplier of wholesale hot tamales in Greenville, but they still find time to take the hot tamale truck and cart out to area communities. *From left*: Aaron, Willie and Lou. *Author's collection.*

This is the scene every Wednesday as members of the Scott family gather at the home of their late parents, Aaron and Elizabeth, to continue making hot tamales using a recipe the couple developed in the 1940s. *Author's collection.*

George Jefferson took his cart off the street to compete in a World Championship Hot Tamale Contest in the early 1980s. *George Jefferson.*

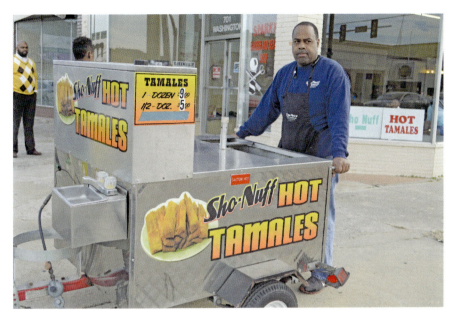

Perry Gibson can be found with his Sho Nuff hot tamale cart on the corner of Washington and Theobald Streets in Greenville most weekends. *Author's collection.*

Every one of Jefferson's hot tamales is hand rolled on the kitchen table, most by Gerald Jefferson. *Author's collection.*

Bundles of freshly wrapped hot tamales ready to be submerged in water for simmering, the final stage in the cooking process. *Author's collection.*

Delta bluesman Robert Johnson sang about hot tamales in "They're Red Hot." Delta artist Karl Wagner captured the spirit of the song in this original painting. *Author's collection.*

Above: Hot tamales are the kind of food good for a casual or formal setting. They can go anywhere. *Author's collection.*

Right: Malcom Dye, Mr. Hot "T" Molly, gets his tamales ready for the judges at the Delta Hot Tamale Festival in Greenville. *Author's collection.*

Above: A pot full of tamales about to be simmered and judged at the Hot Tamale Festival. The rest are sold to festivalgoers. *Author's collection.*

Left: Adrian Sutton loves hot tamales so much she decided she needed to learn how to make them and compete in the Hot Tamale Cooking Contest. *Author's collection.*

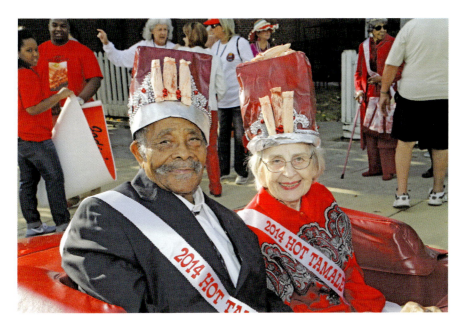

The royal couple of the 2014 Delta Hot Tamale Festival, King Eddie Cousic and Queen Corrine Goodman reign supreme over everything hot tamale. *Main Street Greenville.*

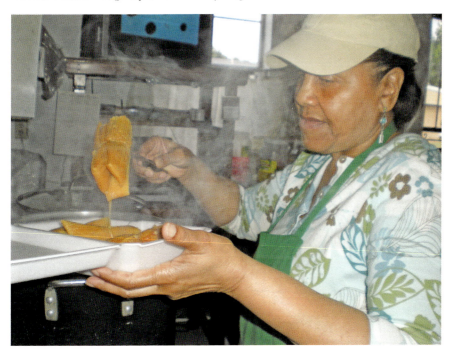

Barbara Pope never intended to be running a hot tamale business, but she is carrying on her brother's legacy at the White Front Café in Rosedale. *Author's collection.*

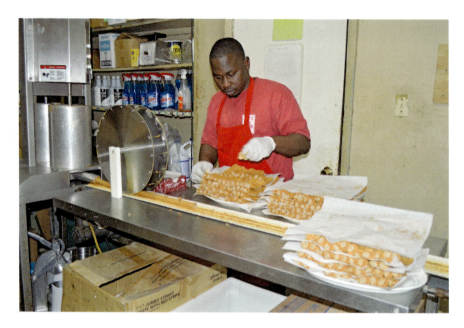

Every Wednesday, Adrian Green can be found making hundreds of hot tamales at the famous Doe's Eat Place in Greenville. *Author's collection.*

Jodie's Hot Tamales of Greenville has taken top honors at the Delta Hot Tamale Festival three years in a row for the spinach tamale. *Author's collection.*

Right: Stuffed bell peppers are kicked up a notch when hot tamales are used as the main ingredient. *Author's collection.*

Below: What's the best way to serve hot tamales? On a hot tamale plate crafted by the Delta's renowned McCarty's Pottery. *Author's collection.*

Delta Fast Food in Cleveland doesn't get in a hurry when making hot tamales. Owner Gentle Rainey says his tamales are so good that they are worth the wait. *Author's collection.*

Perry Gibson of Metcalfe knows exactly how long each tamale is supposed to be just by the feel of his hand. He knows exactly when to separate it from the extruder. *Author's collection.*

Chapter 3

HOT TAMALE
CAPITAL OF THE WORLD

How Hot Tamales Inspired a Festival, Music and a Trail

Ain't nothing in the world like a Delta girl at the hot tamale capital of the whole wide world, eatin' hot tamales.
—from the song "Hot Tamale Boogie" (2014) by Bruce Blackmon

BIRTH OF A FESTIVAL

The city of Greenville sits along the banks of the Mississippi River. For years, it was a bustling port community with river traffic coming and going. Could visitors from up and down the river have played a part in the history of hot tamales and the tradition the town continues to hold dear to this day? No one really knows, but this community is without a doubt the epicenter of Delta hot tamales. More hot tamale makers live in and around Greenville than in any other Delta community. So it was only natural that it would one day proudly bear the title Hot Tamale Capital of the World.

The road to being crowned the official hotbed of hot tamales all began over (what else?) food—hot tamales, to be exact. Betty Lynn Cameron, Valerie Rankin and I were all part of a group of friends who got together on the weekends to cook and enjoy one another's company. The group would gather at one person's home, where they would share a meal prepared by the host. Or a particular category of food was selected, and everyone brought his or her favorite example of that delicacy. There might be only four people one week and then ten the next, but we always had fun and ate some really

good chow. On more than one occasion, the subject of hot tamales came up. Why were they so popular? Why did so many folks in Greenville make them? Who had the best tasting tamale? Why don't we have a festival celebrating this food so synonymous with the Delta?

"We began to ask Betty Lynn (who was executive director of MainStreet Greenville at the time) how to put a festival together, what it would take to get something like this off the ground," Rankin said. "The one thing we knew [was] it was going to be a lot of work, but we felt like it was worth pursuing."

For a while, the idea of a festival was nothing more than talk, a wish, a pipe dream—that is, until a backyard hot tamale tasting.

One weekend, instead of cooking, Cameron, Rankin and I decided for our usual gathering to host a hot tamale tasting. About thirty people were invited to Rankin's backyard. Hot tamales from twelve different businesses or individuals were brought. Only one person knew where the hot tamales were from. Those coming to the party had to check with this person beforehand and declare whose hot tamales they were bringing to the event. This ensured that each hot tamale vendor was represented only once.

Every person got a scorecard and rated the hot tamales. The votes were tallied, and a favorite hot tamale was chosen. It was Jefferson Hot Tamales of Greenville. The day included a jam session with Greenville musician

A backyard hot tamale blind tasting led to the creation of the Delta Hot Tamale Festival. *Author's collection.*

Jessica Brent and her daddy, Howard, taking center stage. There was also a poem written especially for the occasion by Dominick Cross. We dubbed it the first unofficial hot tamale festival.

As we stood in Rankin's kitchen after the tasting was over, we looked at one another and knew immediately we had to put a festival together.

I remember looking at the ladies and saying, "We are going to do this," referring to the festival.

"We didn't have to think about it; we knew this had to happen," Cameron said. "We wanted to share the excitement and fun we had on that Sunday afternoon with everyone else. Hot tamales just make you happy; they are a fun food."

It would be a couple more months before the planning of the festival began. We selected the third weekend in October as the date. That weekend is now known as Hot Tamale Festival weekend. Ideas began to flow for that inaugural event. We began to research in earnest on how to start a festival, visiting websites, going to other festivals and asking a lot of questions. At the center of the event would be a hot tamale–cooking contest. We wanted to give hot tamale makers a chance to showcase their tamales. They would be judged, and trophies would be awarded. There were twenty-one entries in the cooking contest that first year. The contest would be named after the late Frank Carlton, who had held the inaugural hot tamale cook-off some seven years earlier.

Hot tamale makers could prepare their hot tamales at home but had to keep them warm at the festival. Some decorated their booths. Many had on special T-shirts they had made for their tamale teams. The judges visited the booths, talking with the makers and keepers of the hot tamale secret recipes to find out why their hot tamales should be judged the best. Tamale after tamale was consumed. Still other judges were brought Styrofoam boxes of hot tamales marked only with a number. They ate and ate until they, too, had ranked the hot tamales on taste. Once all of the scores were tabulated, the winner was determined. It was Jefferson's Hot Tamales, the same tamale maker that had won the backyard competition a year earlier.

The festival also holds a hot tamale–eating contest, and a young woman is crowned Miss Hot Tamale. And what festival would be complete without royalty? There was only supposed to be one royal, but indecision by a beloved hot tamale maker intervened.

Originally, the king or queen of the festival was to be someone older who had made a significant impact on Delta hot tamale history. Without question, the first person on the short list was Shine Thornton. The

DELTA HOT TAMALES

Left: The annual Delta Hot Tamale Festival is kicked off each year with a parade led by the Hot Ta'Mamas. *From left*: Valerie Rankin, Anne Martin and Betty Lynn Cameron, festival founders. *Bill Johnson.*

Below: Thousands of people swell the streets of downtown Greenville for the 2013 Delta Hot Tamale Festival. *Main Street Greenville.*

only caveat was the king or queen could not also compete in the hot tamale–cooking contest.

When Shine was asked to be the very first festival king, his response of "I'll have to think about it" was not the one we expected. It turned out the award-winning tamale maker wanted to see if he could continue his winning ways. He wanted to cook instead of be king, so he politely declined our offer. Our second choice, Florence Signa, is better known as Aunt Florence. She is part of the renowned Signa family, owners of Doe's Eat Place and famous hot tamale makers. She's the one who makes the famous Doe's salad with the Signa family dressing recipe.

There is no shortage of hot tamales for festivalgoers, 2013. *Main Street Greenville.*

One phone call to Aunt Florence and the debut Delta Hot Tamale Festival had its first royal subject. She was thrilled and humbled to be asked. It was a well-deserved recognition. While Aunt Florence doesn't actually make the hot tamales, she says she loves seeing how much their customers enjoy eating them. "I love it; I love being around people and seeing people happy. Hot tamales are just a fun food and they make you smile."

But two days later, Shine called Betty Lynn and said he had changed his mind. If the festival founders were going to be so kind as to ask him to be king, he wasn't going to turn it down. He would be honored to reign over the festival.

"I love making tamales, and I love it when folks enjoy my tamales. But I love Greenville, and I'm proud to be the king of the hot tamale festival," Shine exclaimed.

Suddenly, the festival had a pair of royals. We decided to keep them both. Since that first year, the selection of a king and queen has changed. There might be two royals, or there might be just one. And those selected to wear the corn shuck crown are older residents who have worked hard, most times behind the scenes, to better their community and pay it forward.

"There are so many good folks around here, we will never run out of candidates to be the king and queen," Rankin added. "The problem now is just making up our minds among so many wonderful, deserving people. It's a good problem to have."

HOT TAMALE CAPITAL OF THE WORLD

Former Greenville mayor the late Chuck Jordan was so excited about the Hot Tamale Festival that he wanted to make sure the entire world knew just how special this event and the tamales that inspired it were. Mayor Jordan began the process of having Greenville declared Hot Tamale Capital of the World.

Bragging rights became official in July 2012, when Jordan declared from the steps of city hall that Greenville would be known as the Hot Tamale Capital of the World. He said it was a great day for Greenville, a hotbed of hot tamales.

The declaration seemed like the natural thing to do. Greenville is on the Hot Tamale Trail and, according to the Southern Foodways Alliance, has more hot tamale makers than anywhere else. Charles Signa, co-owner of Doe's Eat Place, was there that day and said it was great that Greenville was being recognized for its tamales. About the festival, Aaron Harmon, owner of Hot Tamale Heaven, said it had been a long time coming. "We deserve it with the popularity of the tamale in this area and the Delta."

By the time the festival rolled around on October 20, Chuck Jordan had resigned as mayor of Greenville. He was battling pancreatic cancer. But newly elected mayor John Cox took up Jordan's charge for the festival. And the self-proclaimed Hot Tamale Capital of the World. During the next year, Cox worked diligently to register and trademark the declaration. Greenville would forever and always carry the title.

HOT TAMALE MUSIC

Hot tamales have found their rightful place in blues music, which is no surprise since both sprang up right here in the Mississippi Delta. According to the Southern Foodways Alliance, in January 1928, the popularity of hot tamales among both blacks and whites was such that the Reverend Moses Mason recorded a song called "Molly Man." Included in the lyrics are the lines "Good times is comin'/Don't you see the sign?/White folks standin' round here, spending many dimes." At the time, tamales cost about thirty cents a dozen. Mason was a native of Louisiana but recorded the song in Chicago at the same time he laid down the tracks of four gospel songs and two sermons. It was during this same session that he recorded two secular songs, but they were credited to Red Hot Ole Mose.

MOLLY MAN

by Reverend Moses Mason, recorded in 1928

Two for a nickel, four for a dime
Thirty cents a dozen, and you'll sure eat fine

I can judge by the way you walk
You gonna carry half a dozen off

Good times is comin', don't you see the sign?
White folks standin' round here, spendin' many dimes

'Males so hot, just burns my hand
So that I can hardly get 'em out of my can.

A few years later, about 1936, legendary Delta bluesman Robert Johnson recorded "They're Red Hot," a slightly more suggestive tune that could be about hot tamales or a woman, as the term "hot tamale" was used to describe a sexy-looking woman. Over the years, this song has been covered by various artists, including Eric Clapton, a big fan of Johnson's.

Many years ago, hot tamales cost sixty cents a dozen. Now folks are still willing to pay twelve dollars or more. *Author's collection.*

EXCERPT FROM "THEY'RE RED HOT"

by Robert Johnson, recorded in 1936

Hot tamales and they're red hot, yes she got 'em for sale
Hot tamales and they're red hot, yes she got 'em for sale
I got a girl, say she long and tall
She sleeps in the kitchen with her feets in the hall
Hot tamales and they're red hot, yes she got 'em for sale,
I mean
Yes, she got 'em for sale, yeah

After the Delta Hot Tamale Festival kicked off, Greenville native and national recording artist Bruce Blackmon penned and recorded "Hot Tamale Boogie" for the festival. In an excerpt of the lyrics, folks are welcomed to Greenville and the festival and are promised seeing the hot tamale boogie:

Ladies and Gentlemen, we take you to downtown Greenville, Mississippi
Where people from all over the world come right here
To the Hot Tamale Festival.
People cross the world come from near and far, right here in the Delta, right
 where you are,
To the festival, we tell 'em hi y'all!
See the hot ta'mama's do the hot tamale boogie tonight.

"I wrote this especially for the festival, for my hometown and because hot tamales are just fun," Blackmon explained. "Why not sing about something we all enjoy?"

Tamales have been showing up in American music since about 1900 in such genres as ragtime, zydeco, Dixieland jazz, the blues and even hip-hop. According to Gustavo Arellano, author of *Taco USA: How Mexican Food Conquered America*, there are now songs devoted to tacos, tequila and many other Mexican foodstuffs, but no food has more songs written about it in America than hot tamales, a testament, he says, to the staying power of masa wrapped in a corn husk.

Hot Tamale Trail

With a food as alluring as hot tamales, why not have a trail of hot tamale vendors around the state? You could travel from one hot tamale stand to another, comparing the taste and technique and meeting the folks who make them. While it's not the Natchez Trace, this trail has been followed by hundreds as they search out the best tamales around and get a nice tour of the state to boot.

The Hot Tamale Trail was established by the Southern Foodways Alliance in 2005 to document the beloved hot tamale and those who are part of the tradition. Amy C. Evans was the oral historian for the SFA. The first person she interviewed was Barbara Pope at the White Front Café in Rosedale. The project was dedicated to Barbara's brother Joe Pope, original owner of the White Front, who passed away in 2004.

Viking Range Corporation partnered with the SFA to create the Mississippi Delta Hot Tamale Trail as a way to document the history, tradition and culture of hot tamales from Tunica to Vicksburg. The trail would give cultural tourists a complete guide to a unique culinary experience.

As a matter of fact, the Southern Foodways Alliance is centered on food. The organization documents, studies and explores the diverse food cultures of the changing American South. It is a member-supported organization based at the University of Mississippi's Center for the Study of Southern Culture. It collects oral histories, produces films and podcasts, publishes writings about food, sponsors scholarships, mentors students and hosts events about the South.

The SFA was established in 1999 in Birmingham, Alabama. John T. Edge has served as director of the SFA since its founding. You can find out more about the SFA and the Hot Tamale Trail at www.southernfoodways.org.

Chapter 4

AW, SHUCKS!

The Secrets and Allure of the Delta's Favorite Food

There are three things that aren't secret about a hot tamale—texture, taste and juice.
—*Eugene Hicks*

Hot tamale recipes are as guarded as intelligence reports at the Pentagon. No one wants to give them up. The basic ingredients are the same, but don't ask how much seasoning goes into the pot—you ain't gonna get it. You will get a polite "I can't tell you that" followed by a smile. One tamale maker, Eugene Hicks, said someone might have to die if the secret ingredient in his hot tamales was ever revealed. He followed up his comment with a big grin but a look that said, "I'm not kidding." But why is this recipe so special, unlike, say, your mother's recipe for macaroni and cheese? Again, no straight answer.

While the basic recipe and technique are the same, the secrecy is all about the seasonings. How much chili powder or cayenne pepper to use? Do you season your meat or the cornmeal? And some hot tamale makers go so far as to not divulge what cut of meat they use. What gives? Is the world going to come to an end if the exact ingredients and amount of spices are shared with the rest of modern civilization? That is very doubtful, but don't try prying that information out of someone who makes Delta Hot Tamales. They'd rather tell you the PIN for their debit card.

Rhoda Adams at Rhoda's Famous Hot Tamales and Pies in Lake Village, Arkansas, says she doesn't know what is going to happen to her hot tamale recipe. She has worked hard over the years to develop her own recipe, but

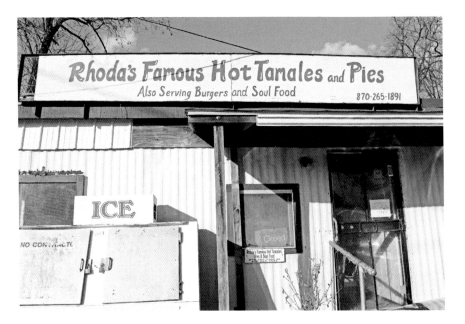

Rhoda's Famous Hot Tamales and Pies is one of the few places to get hot tamales in Lake Village, Arkansas. *Author's collection.*

she's not going to share it with anyone. She will tell you what kind of meat she uses, but that is all the information she is willing to part with.

She's not even sure with whom she is going to share her secret to carry on the hot tamale tradition when she dies: "I don't really care about passing on the recipe. I'll be gone."

For years, only one person at Doe's Eat Place in Greenville, Mississippi, knew the hot tamale recipe and how to make them: Big Doe Signa. When Signa opened a restaurant in 1941, he began selling hot tamales using a recipe he had been given. After adjusting the instructions to make it his own, he didn't share it with anyone except his wife, Mamie. The recipe hasn't changed in all these years at the iconic Delta eatery, though, today, a few more family members know how to make the hot tamales.

In the beginning, Big Doe was the only one who mixed up the seasonings for the meat. According to his sons, Charles and Little Doe, their daddy would get them up about two thirty in the morning to go help make hot tamales. This would be after waiting on customers at the restaurant the night before.

"We did this for two days, Tuesday and Wednesday," Charles Signa said. "On Tuesday, we would cook the meat and cool it for making the tamales the next day."

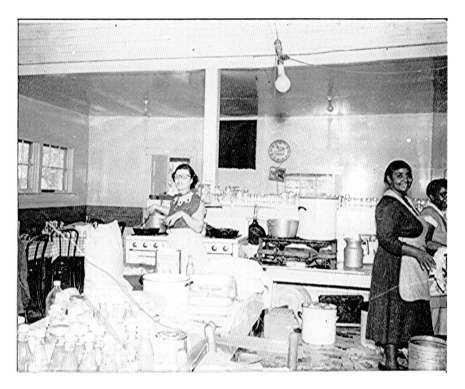

Mamie Signa (left) stands in the kitchen of Doe's Eat Place along with two unidentified cooks. She and her husband, Big Doe, opened the restaurant in the 1940s, serving steaks and hot tamales. *Signa family.*

The early morning ritual went on for twenty to thirty years, the younger Signa said. It was primarily done so it didn't interfere with the running of the restaurant. But it also helped keep *the* secret.

"By making the hot tamales at night, we didn't run the risk of anyone walking in while Daddy was putting in the seasoning and seeing what he was doing."

After a while, Charles and his brother, Doe, were allowed to handle the seasoning. And it is still a family thing. The brothers have passed on the family secret to their sons, who help with restaurant.

"When Daddy was here, before he retired, he would have the doors closed," Charles added. "He wouldn't let nobody back there until he was done."

Charles, Doe and Florence all said they have no idea why the hot tamale recipes are so guarded.

"That's just the way it is," Doe said. "It's like barbecue in Memphis. You're not going to get a sauce recipe either."

Similarly, Gentle Rainey at Delta Fast Food in Cleveland doesn't want to divulge what kind of meat he uses to make his hot tamales, although he will share that he has tested out different kinds and cuts of meat to find the one that holds the seasonings the best. Oh, and he's not going to tell you what kind of seasonings he uses either.

"I got my recipe from my grandfather, and I have made some changes to it over the years," Rainey said. "Mine are not hot, hot. They are more mild. But they are good."

So what makes them so good? "Old family recipe," he said, smiling.

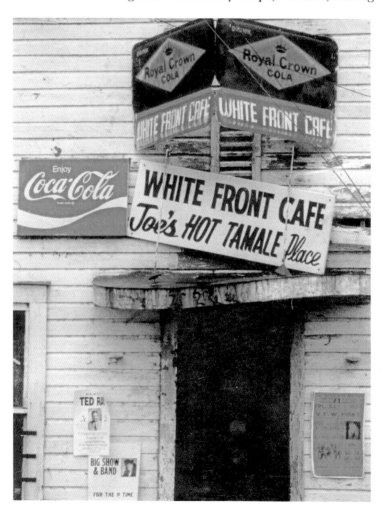

The iconic photo of Joe's White Front Café in Rosedale, where Joe Pope made his famous hot tamales. *Debra Ferguson.*

Aw, Shucks!

Joe Pope's recipe almost went to the grave with him.

Pope was running the White Front Café/Joe's Hot Tamale Place in Rosedale when his sister Barbara returned home in 1999 to help care for their ailing mother. It turned out, Joe was the one who became ill and needed looking after, and so did the café.

As Joe's condition deteriorated, Barbara realized she was going to have to run the restaurant. And that meant learning the secrets of how to make those famous hot tamales. Joe didn't give up the recipe until just before he passed away. Now Barbara is the only one who knows the secret. What she isn't so sure about is to whom she will pass it along.

The Scott family of Metcalfe developed their secret recipe after a lot trial and error. That recipe has earned them a reputation as one of Greenville's most famous tamale-making families. Aaron and Elizabeth have both passed away, but their children now keep the family recipe and

run the tamale business. They plan to pass it along to some of the grandkids, if anyone is interested.

At the Onward Store in Onward, hot tamales have been on the menu for at least two decades. The business has changed hands a few times in the past twenty years, but not all of the owners have been privy to the tamale recipe. According to Linda Agee, cook at the restaurant, not even current owner, Mollie VanDevender, knows the secret of the Onward tamales.

"As the store has changed ownership over the last twenty years, the hot tamale recipe has been passed on, too," Linda said. "But I'm the only one who knows it."

So what is going to happen to that recipe when

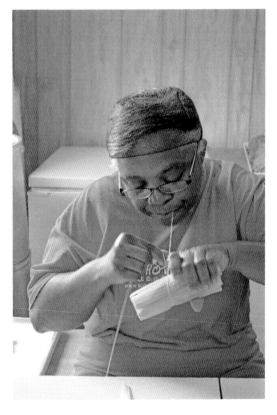

Marie Benson makes quick work of tying hot tamales for Scott's Hot Tamale. *Author's collection.*

Linda Agee is the only person who knows the secret recipe to the hot tamales at the Onward Store. *Author's collection.*

she's not around to make them anymore?

"Guess it will die with me," she said with a wink and a smile.

Native Mississippian and cookbook author Susan Puckett says one of the magical ingredients of hot tamales is the practice and hard work that has been learned through the generations. "I think it is because of the hard work that has gone into developing the recipe that folks are a bit reluctant to share their recipe. They have worked hard for it."

Some hot tamale recipes are in danger of being lost forever. Since they are not written down, they may never be known to others. This could happen to Eugene Hicks's recipe.

Hicks has been in the restaurant business for forty-five years, but he is ready to retire and step away from Hicks World Famous Hot Tamales and More. But he's not sure what the future holds for his restaurant, much less his hot tamale recipe. When asked what happens to his recipe if he and his wife, Betty, decide to close up, he said, "I guess it will be over." The hope is a buyer will come forward and the tradition of Hicks's hot tamales will continue.

Meg McGee, general manager of the Airport Grocery in Cleveland, said she thinks the recipes are closely guarded for a reason. "It is something people take a lot of pride in. They've worked hard to get that recipe just like they want it," she said. "It represents something to them that it can't to anyone else."

Juke Joint Tamale Company owner Mark Azlin feels the recipes are kept so close because not many folks know how to make hot tamales. "The few

people that do know how to make tamales don't want to give up the secret," he said. "Someone made money off that recipe."

It's no secret there is an attraction between the Delta and hot tamales. But why? For Azlin, it's the way he was brought up; it's memories and not being able to have something all the time. "We usually reserved hot tamales for special occasions and that, in turn, made them special."

The late Frank Carlton, Greenville hot tamale connoisseur, knew tamales were special. "I'm hard-pressed to tell you what makes a good hot tamale. It's sort of like pornography: I know it when I see it. I mean, I can describe it OK. All right, now my point is a good hot tamale is hard to describe and—and there are varieties of hot tamales."

Amy C. Evans, lead oral historian with the Southern Foodways Alliance Hot Tamale Trail, said she can't believe people are still making them by hand. The process of making hot tamales is extremely labor intensive. Hands touch every single tamale made.

"Mississippians are not going to let go of the tamale makers. They are not going anywhere."

As Evans traveled the Tamale Trail, she had the opportunity to speak with a number of tamale makers, to hear their stories and see firsthand how every hot tamale maker is different. She said Delta tamales taste different. Delta tamales are unique.

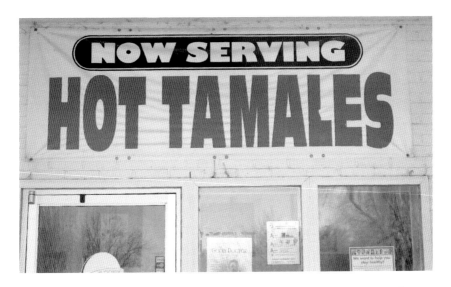

Signs like this one are popping up at such places as snow cone stands, doughnut shops and convenience stores, making hot tamales even more available. *Author's collection.*

Every week, hands like these are busy rolling countless hot tamales across the Delta. *Author's collection.*

"We have grown up around them. They have always been here," said Hank Burdine, commissioner with the Mississippi Levee Board and professional hot tamale eater.

"It's hard as hell to make hot tamales," Burdine said. "Those that refine that recipe, they don't want to give it out, and I don't blame them."

Burdine says he loves to eat them. His favorite way to consume this Delta specialty is like a push-up ice cream bar. Put the tamale in your mouth and push it from the bottom of the shuck so the tamale comes out of the shuck at the top. Dip it in some ketchup for some added flavor.

"You get it all over your hand but you get all the juice that way."

Puckett added that hot tamales are all about traditions and keeping those traditions going. She says one of the magical ingredients in the tamales is the practice and hard work that has been learned from generation to generation.

While the recipes are being handed down from generation to generation, they aren't leaving a certain area of the Delta. There are more hot tamale makers in northern Washington County and southern Bolivar County in Mississippi than anywhere else. Perry Gibson offered up this reason: "Tamale makers are guarding their recipes and other tamale secrets so closely those secrets can't hardly get out of the Delta."

Chapter 5

YOU CAN'T SAY HOT TAMALE WITHOUT SMILING

Using Fruits and Veggies in Tamales and Tamales in Other Recipes

Red hots! They're red hot!
—chant used by hot tamale vendors as they push their hot tamale carts
through a neighborhood

Hot tamales, served most often with saltine crackers and a bottle of hot sauce, are a popular appetizer at Delta parties and suppers. Cut off a bite, sit it atop the cracker and pop it in your mouth. What goes on hot tamales is as varied as the recipes used to make them. Ketchup is a poplar condiment for dipping hot tamales, and generous dashes of hot sauce or squeezes of lemon juice are also used. Still others—such as K.K. Kent, who has been making hot tamales at K.K.'s Deli in Greenwood, Mississippi, for twenty-two years—prefer ranch dressing. And the staff at the Onward Store swear sour cream is the best way to eat a Delta hot.

While there are a few different ways to dress a tamale, the way to handle a hot tamale is the same whether you are at a roadside stand or an upscale restaurant: pick it up with your fingers. It's like fried chicken; there is just no way to eat it without using the two best utensils God gave you.

Using both hands, hold the hot tamale horizontally and grab the edge of the corn shuck. With a little gentle prodding if needed, the hot tamale will roll right out and onto the plate. Dispose of the empty shuck on the shuck plate that is always in the middle of the table. From that point, you are on your own about how you want to eat it. There is no right or wrong way to consume a Delta hot tamale.

DELTA HOT TAMALES

K.K.'s Deli in Greenwood serves up spicy hot tamales with cool sides, such as homemade potato salad or slaw. *Author's collection.*

Hot tamales were invented as a portable food to be eaten in the field, and there are a few connoisseurs who still like to eat them to reflect that. For this method, put the open end of the hot tamale in your mouth and gently squeeze from the bottom, pushing the tamale up to your lips.

Hot tamales are a meal unto themselves, but adding a side dish, such as a fresh green salad, can make it more like an honest meal. But that is by no means necessary.

K.K.'s Deli offers potato salad or coleslaw with its hot tamales. "The potato salad or coleslaw is a nice way to counterbalance the heat in the tamales," Kent said. "We make the sides fresh, just like the hot tamales."

Many restaurants will serve chili poured over a plate of hot tamales and sprinkled with cheese. In the past few years, courageous cooks have come up with some pretty tasty ways to use hot tamales in a variety of recipes. From appetizers to main dishes and desserts, hot tamales are now being consumed in ways other than with just a saltine cracker and hot sauce.

Hattie Johnson of Jodie's Hot Tamales in Greenville began making a vegetarian hot tamale a few years ago at the request of a friend. "I have a friend who came to visit from Atlanta, and she had a friend who wanted

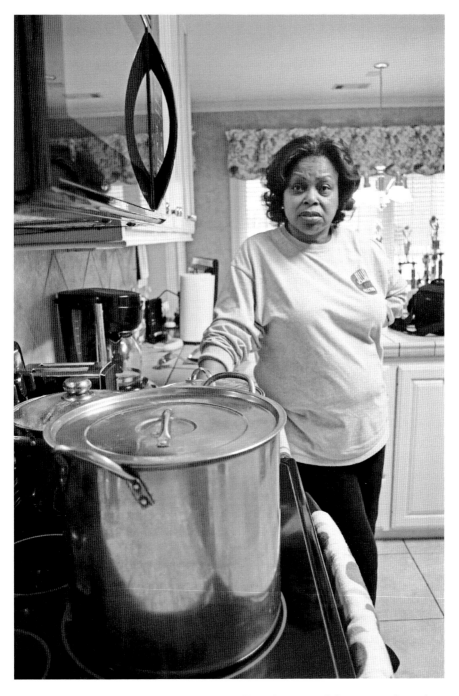

Hattie Johnson knows her way around a tamale. Her spinach tamale has garnered grand-champion status three years in a row at the Hot Tamale Fest. *Author's collection.*

tamales but was vegetarian," Hattie said. "She said I could just make her a masa tamale. I told her that wouldn't do."

That's when Hattie began searching the Internet for a meatless tamale. After some experimenting, Hattie came up with a recipe using spinach, cheese and roasted tomatoes. It took her only a couple tries before she landed on the recipe she currently uses. "My regular hot tamale customers love them as much as the folks who are looking for something vegetarian." Since these tamales are a bit more time consuming, she makes them only every four to six weeks while she produces her traditional meat tamales on a more regular basis.

The spinach tamale is firm and can be easily cut into thirds for a simple pickup appetizer in addition to a meal. The flavor is bold enough that it doesn't need a condiment. Hattie has also made tamales using shrimp and another with beans.

Adrian Sutton of Jenny's Twice the Heat Hot Tamales in Memphis came up with a vegetarian version of her tamale after some friends put in a request for a meatless version. Pinto beans take the place of the meat. "It's good and gives folks who can't or don't want to eat a regular tamale a chance to enjoy a Delta hot tamale," Adrian said. "No one should have to miss out on enjoying a good tamale."

Some of the most adventurous tamales have come from Poppa Doc's Big Fat Tamales and are made by Greg Harkins of Jackson. Greg, a renowned chair maker by trade, has translated his creativity to the kitchen when it comes to hot tamales. Chocolate has found its way into a dessert tamale, and a shrimp and grits tamale is a Lowcountry-meets-Delta kind of dish. He has also made tamales using venison, lobster, rabbit, squirrel and duck.

"I always want my tamales to be the best they can be," Greg said. "And I want my tamales to be something special you aren't going to get anywhere else." He began making hot tamales after his ex-wife opened a bakery that ultimately didn't do too well. He was looking for something that could stand on its own. That's when he thought about hot tamales. He started off making what he called a cocktail tamale, a Delta tamale. But what he really wanted to make were his version of the tamales he discovered on a trip to Mexico.

"I went on a great tamale hunt during a trip to Mexico and found these large, plump creations."

The first place he stopped, he ordered a tamale as an appetizer that cost four dollars. When it arrived, it was four inches across and about eighteen inches long and curved. Greg says it was excellent.

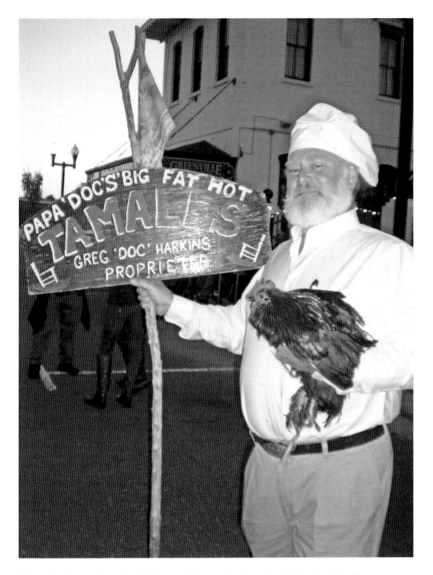

Greg Harkins adds a bit of flair and fun to his Papa Doc's Big Fat Hot Tamales not only in his presentation but also in the ingredients he uses. *Author's collection.*

His tamales are three to four times bigger than the traditional Delta hot tamale. He uses masa and corn shucks, but the insides are anything but beef or pork. His first tamales were chicken, but he soon began to venture out to more exotic tastes. One of his most popular tamales is his shrimp and grits creation. A shrimp tamale is laid on a bed of cheese grits and topped with chipotle pepper sauce and lime juice. One of these will cost you about the

same as a dozen Delta hot tamales: ten dollars. Or you can get a dozen for fifty dollars. "I don't sell too many dozens; I don't want to. I'm more of the one-tamale-at-a-time guy."

All of Greg's tamales are handmade. He purchased a machine years ago and used it a few times, but he ended up casting it aside. He said he just liked the way the tamales came out when he used his hands.

As for his recipes, they are totally and completely made up. Harkins knows his way around a kitchen, so he knew that the first recipe for hot tamales he tried off a bag of masa needed some help. He likes to experiment with mixing flavors, adding spices and tweaking the ingredients until he is satisfied. One item he likes to use in all of his tamales is nuts—any kind of nuts, from pumpkin seeds to sunflower seeds and almonds. He steers away from pecans because the flavor can be overpowering.

Greg sells his tamales at craft and art shows. You can also call him up and place an order. He has hosted tamale dinners and tamale-making lessons for groups of ten.

"I just have fun with it and want people to enjoy them. Besides, isn't that what life is all about?"

There are many hot tamale recipes out there and a variety of ways to eat them, and there are just as many ways to cook with hot tamales. And the fact that you are using a meat that has already been cooked makes the preparation that much easier. A number of recipes are offered here that can give your hot tamales a new look and a surprisingly new taste. These kitchen creations are great for small, informal gatherings or black-tie events.

But what beverage do you serve with your hot tamales, whether plain or dressing up? Ice-cold beer has long been a preferred choice, but you are not limited to a brew. If you are looking for something a little more sophisticated, try a nice Zinfandel. Bottom line, hot tamales, in all forms, go great at any party and pair nicely with the cocktail of your choice. Bon appétit!

Fried Hot Tamale Pies

cooking oil
1 dozen hot tamales from your favorite hot tamale maker
1 can whole-kernel corn, drained
1 can petite-diced tomatoes, drained

1 small can black olives, drained
3 green onions, chopped
½ cup colby jack or Mexican blend shredded cheese
1 package pie crust (kind that can be rolled out)

In a large cast-iron skillet, pour oil to about 1 inch deep. Heat oil on medium high heat.

Meanwhile, unwrap 6 to 8 hot tamales, depending on the size. Add more if tamales are small. In a large mixing bowl, mash hot tamales. Add about ¾ cup corn and ¾ cup tomatoes. Add olives and onion. Stir into hot tamales. Fold in ½ cup shredded cheese.

Unroll one pie crust at a time onto a lightly floured surface. Using a rolling pin, roll the dough a few times to make it slightly thinner, being careful not to tear the dough. Cut into rounds the size of a martini glass. (A martini glass was used when testing this recipe.) Place 2 tablespoons of tamale mixture on one side of the dough round. Fold dough over tamale mixture. Using the back of a fork, seal edges of dough. Repeat process with second pie crust. Make all pies before frying, as the frying process is quick.

Drop hot tamale pies into hot oil. Cook until golden brown, then turn over. Fry about 2 to 3 minutes per side. Remove with a slotted spoon and let drain on paper towel.

Great served warm or at room temperature with guacamole and sour cream.

Hot Tamale—Stuffed Peppers

4 bell peppers, any color, tops removed, cleaned and cored
10–12 hot tamales (depending on size), unwrapped
1 can shoe peg corn, drained
1 can fire-roasted diced tomatoes, drained
1 cup colby jack shredded cheese

Preheat oven to 375 degrees. Steam bell peppers just to soften slightly and remove outer film. Pat dry and place upright in a casserole dish.

DELTA HOT TAMALES

In a large mixing bowl, mash up hot tamales. Add corn, tomatoes and a generous cup of cheese. Stir together with hot tamales. Put hot tamale mixture into bell peppers.

Bake at 375 degrees for about 30 minutes, until warm in the center. Remove from oven and sprinkle shredded cheese on each bell pepper. Cook an additional 5 minutes, or until cheese is melted.

Serve warm.

Hot Tamale Surprise

1 can crescent rolls
6–8 hot tamales, unwrapped
4 green onions, chopped
1 4¼-ounce can sliced black olives, drained
½ cup black beans, drained and rinsed
1 small- to medium-sized tomato, diced
1 cup sharp cheddar cheese, plus a little extra

Preheat oven to 375 degrees. Unroll crescent rolls. Place wide ends of crescent roll in the center of a pizza stone or heavy cooking sheet. Mash wide ends together, closing up any gaps.

Hot Tamale Surprise is a fun appetizer with hot tamales as the main ingredient. *Author's collection.*

Coarsely chop the hot tamales. Add onions, olives, black beans and tomato. Mix together and then stir in cheese. Place hot tamale mixture by the spoonful into the center of the crescent rolls. Do not pile too high. Lightly mash down the mixture if necessary. You may not use all of the mixture. Take pointed ends of the crescent rolls and bring them up and over the hot tamale mixture. The seams along the side may be open.

Bake at 375 degrees for about 20 minutes. Remove from oven and lightly cover with foil. Return to oven and continue to bake for 20 minutes.

Let cool slightly before serving.

Hot Tamale Dip

2 dozen hot tamales
1 bunch green onions, chopped
4 cups chili
3 cups grated sharp cheddar cheese

Preheat oven to 350 degrees. In a large bowl, mash hot tamales. Mix in onions and 1½ cups chili. In a greased 9- by 12-inch casserole dish, layer three times the tamale mix, remaining chili and cheese. Bake uncovered at 350 degrees for about 30 minutes, or until bubbly. Serve warm with Fritos.

Hot Tamale Dog

hot dog buns
butter
hot tamales
chili
shredded cheese
coleslaw

Spread hot dog bun with butter and lightly toast. Place one to two hot tamales (depending on the size) that have been warmed in the

microwave on the bun. Cover with warm chili. Add a generous amount of shredded cheese. Top with coleslaw.

Note: Yes, this sounds like a heart attack waiting to happen, but boy is it good (as are all of these recipes)! The idea for this one was sparked as I was eating hot tamales for lunch one Saturday, and for some unknown reason, hotdogs became part of the conversation. I immediately began to wonder what a hot tamale would taste like on a hot dog bun. I interrupted my own lunch and made a quick trip to the local Piggly Wiggly for chili and hot dog buns. Since everything is better with butter, the bun was slathered and toasted. Once the unwrapped hot tamales were placed in the bun, the chili, cheese and slaw were added. Heaven help me! It was that good.

Little did I know that I had partially re-created the mother-in-law sandwich, a popular dish in Chicago. That version is just the tamale on a hot dog bun topped with chili or peppers and onions

The tamale went north during the Great Migration when African Americans from the South were in search of better jobs and a better social climate. Along the way, the mother-in-law sandwich was born. It's unclear exactly how the sandwich got its name or was created in the first place, and it doesn't really matter. Just put a hot tamale on a hot dog bun and enjoy!

Hot Tamale Wrapped in Bacon

1 dozen hot tamales
16 bacon slices, cut in half

Preheat oven to broil. Remove hot tamales from shucks. Cut each hot tamale into 3 pieces about 1 inch long. Wrap bacon strips about cut ends of hot tamales. Trim bacon as needed to wrap neatly. Secure bacon with a toothpick. Broil until bacon is crisp. Serve warm or at room temperature. (Inspired by Mrs. Henry Self of Marks. This recipe was in *Delta Magazine* and published in *Our Delta Dining Cookbook*, 1970.)

You Can't Say Hot Tamale Without Smiling

Simple Delta Tamale Pass Around

1 dozen hot tamales
saltine crackers
several bottles good hot sauce

Remove corn shucks from hot tamales. Cut tamales into pieces about 1½ inches long. Place one tamale piece on a cracker. Put crackers on your favorite tray along with a bottle of hot sauce. Pass among your guests.

WHILE MISSISSIPPI DELTA hot tamales are traditionally simmered, there are some great recipes using the basic ingredients and methods for making veggie tamales that are steamed. We offer a couple here.

Vegetarian Tamales with Spinach, Corn and Cheese Filling

FILLING
2 teaspoons oil
1 small onion, chopped
2 cloves garlic, finely minced
1 small green pepper, chopped
1 cup corn, fresh or frozen
1 cup frozen spinach, thawed
½ teaspoon cumin
½ teaspoon chili powder
salt and pepper to taste
1 8-ounce package shredded colby jack cheese

Heat oil in a pan. Add onion and cook until translucent. Stir in the garlic and cook for 30 seconds, or until fragrant. Add green pepper, corn and spinach. Cook covered until the veggies are tender, about 3 to 5 minutes. Stir in cumin, chili powder, salt and pepper. Mix well and turn off heat.

DELTA HOT TAMALES

CORN SHUCKS
While the filling is cooling, prepare the corn shuck. Dried shucks need to be soaked in warm water prior to using to make them soft and pliable. Fill a deep pan with warm water and soak for about 15 minutes. Soak additional shucks in case a shuck tears during the process. You will also need a few to line the bottom of a steamer basket. When the shucks are ready, drain and set aside.

PREPARE THE STEAMING EQUIPMENT
Set up the steaming basket. Fill the pot with 2 to 3 inches of water. Keep water level below the steamer basket. Line the bottom of the basket with a few corn shucks.

MASA DOUGH
¼ cup vegetable shortening
¼ cup margarine
1¾ cups masa mix (available in most grocery stores)
1 teaspoon baking powder
½ teaspoon garlic powder
¼ teaspoon salt
1½ cups vegetable stock (may use canned)

In a large mixing bowl, with a handheld mixer or a stand mixer, cream together the shortening and margarine until creamy and light. Sift in the masa, baking powder, garlic powder and salt, then continue to beat for about three minutes, until a sandy looking mixture forms. Pour the vegetable stock into the masa mixture and continue to beat until all the liquid is absorbed and a fluffy dough forms, about five minutes. The tamale dough should have a moist, almost mashed potato consistency and should be easily spread with a rubber spatula. If the mixture appears too wet, sprinkle in a little more masa. If too dry, drizzle in a little vegetable stock until you reach the desired consistency. Use dough immediately.

ASSEMBLE THE TAMALES
For each tamale, spread a generous ¼ cup of dough down the center of a pliable, soaked corn husk, leaving at least 1½ inches on either end and at least a ½ inch on either side. This will form a rectangle roughly 4 to 5 inches wide and ⅜ to ½ inch thick

and about 5 inches long. Spoon 1 generous tablespoon of filling down the center of the tamale dough, then top with a little of the grated cheese.

Grab both the edges of the corn husk that are not covered with dough. Bring the edges toward each other and push the sides of the masa dough together to encase the filling. Gently press the side of the tamale to form a firm, solid tube shape. Tightly twist each end of the tamale wrapper and tie with a soaked corn husk strip. You can also use kitchen twine to tie the tamales. Repeat until filling and dough are gone.

About halfway through the tamale making, turn on the eye where your tamale pot is to get the water hot for the steaming process.

Steam the Tamales

Place the tamales in the steamer basket and steam for at least 55 minutes or up to 1 hour, 5 minutes. Check the pot occasionally to make sure that the water has not completely evaporated; add more hot water as needed.

Test to see if the tamales are ready by removing a tamale and peeling back some corn husk. Fully cooked tamales will be tender but solid, not wet. Remove the entire basket from the pot, place on a dinner plate and let stand, covered, for at least 15 minutes to cool. Handle the tamales carefully as they will be very hot.

Serve the tamales with any chili sauce, plus beans, rice or salad, if desired. Don't eat the corn husks! Tamales can also be frozen. Cool the tamales completely, then stack them into plastic bags and freeze them for up to a few months. Frozen tamales can be microwaved until hot.

Spinach, Pepper Jack and Roasted Red Pepper Tamales

6 to 8 large, dried corn husks
2 cups masa
1 teaspoon baking powder
½ teaspoon salt
⅓ cup butter-flavored spread (can use vegetarian spread)
1½ to 2 cups vegetable broth or stock
1 cup coarsely chopped fresh spinach

DELTA HOT TAMALES

¾ cup cubed pepper jack cheese
½ cup chopped roasted red peppers
3 green onions, chopped

Place corn husks in hot water and let stand for 15 minutes to soften. Remove and blot off excess water.

Stir together masa, baking powder and salt in a large bowl. Add butter-flavored spread and mix again. Using an electric mixer, beat in enough stock/broth to form a soft dough. Stir in remaining ingredients

Place equal amounts of mixture on the center of each corn husk. Fold in the sides and then the top and bottom. Place in a steamer basket, folded sides down. Cover and cook over medium-low heat for 45 minutes to 1 hour. Best if served immediately with desired toppings.

Chapter 6

ON A ROLL

The Art of Making Hot Tamales
by Hand or Machine

People who love to eat are the best people.
—Julia Child

Making hot tamales is not an easy task. More time consuming than difficult, it takes at least two days and more than one person, especially if you are making dozens. And most veteran hot tamale makers say it takes a few rounds in the kitchen before perfecting a recipe. But across the Delta, folks have tried it. Some stick with it while others say it is easier to buy them from someone else who has the time and patience.

There are only two options on how to how to make the actual tamale: by hand or machine. The hot tamale machine is widely used, yet some tamale makers swear hands are the best tools in the kitchen in forming the tamales.

One tamale machine manufacturer in San Antonio says its machine can produce up to four hundred tamales an hour and is priced just under $4,000.

Yet another company in Fort Worth touts its product as the "perfect tamale-making machine for just under $1,000." There are wall-mounted machines, machines that sit on a table, hand-cranked machines and electric pedal–operated machines. There is even a long table that connects to some machine that spits hot tamales out on what looks like a mini conveyor belt.

Probably one of the most famous hot tamale machines was retired in 2006 after years of dedication and hard work. This machine was at the center of the tamale-making business at Doe's Eat Place in Greenville.

Delta Hot Tamales

The hand rolling of the hot tamale is one part of the process that can be done by only human hands. *Author's collection.*

According to Charles Signa, his father, Dominick "Doe" Signa, got the machine from a company in San Antonio, Texas. Before the machine, they made the hot tamales entirely by hand. The machine was purchased about 1950 and put in more than fifty years producing an estimated fourteen million hot tamales.

It sat in a corner of the restaurant for years taking up valuable space before it found a new home at the Greenville History Museum. Curator Benjy Nelken was delighted to add this piece of Greenville and hot tamale history to his collection. The machine, which still works, is rather long, with two metal tubes for holding the meat mixture and the cornmeal. A conveyer belt is part of the table and moves the hot tamales along as each new tamale is spit out of the machine. A newer, smaller machine is now used at the restaurant.

Hot tamale machines typically have two metal tubes or cylinders. One is packed with the meat mixture, which has been chilled overnight after being cooked the day before. The other tube is for the cornmeal or masa mixture. The machines are run either by a hand crank, the preferred choice for the Scott family, or an electric one like that used by Sho Nuff. At Doe's, their machine has a foot pedal.

The majority of hot tamale makers use machines to form the actual tamale. *Author's collection.*

As the meat and cornmeal or masa is pushed down into the cylinders from the top, the newly formed hot tamale is pushed out of a spout in the front. A small tube is attached to each cylinder, each about the diameter of a hot tamale. The tube for the meat is slightly smaller than the cornmeal tube. As the tamale comes out, the cornmeal and the meat merge together to form the hot tamale. How long the tamale will be is determined by the person operating the machine. At Doe's, a thin wire cuts the hot tamales to a desired length as the conveyer belt moves the tamales down the line. This is one of the very few hot tamale tables used in the Delta. Locally, the majority of the hot tamale makers use their hands to cleanly break off the tamale at the desired length.

As the tamales come off the machine, they are lined up on trays, layered with wax paper and stacked five or six high before being passed on to the person who will be rolling them in shucks. If the roller isn't ready, the tamales may be placed in the refrigerator to keep them cool and make them easier to handle.

Machine tamales are very uniform, which makes it easy to spot a handmade one. Susie Ervin of Rosedale has been helping hand make hot tamales at the White Front Café for years. She started out working with the original owner, the late Joe Pope, and continued working for his sister Barbara, who took over the business when her brother died.

"It's just a feel. I feel it with my hands," Susie said while making up the latest batch of tamales. "I've been doing this for so long I just know how much."

While hardly paying attention, Susie slips her hand into a bowl of the cornmeal mixture. Holding a generous portion in her left hand, she pinches off just the right amount between her thumb and first two fingers. She lays it on one of about twenty corn shucks spread about before her. As she puts it down, it is flattened slightly, making it ready for the meat mixture to follow.

Once the cornmeal mixture is on all of the shucks, Susie repeats the procedure, this time with the meat mixture. As if her fingers have eyes, she knows exactly how much to put on each tamale. When she's done forming them, the tamales measure only about two inches long. She then rolls the corn shuck around the tamales and ties them in bundles. As the tamales cook, the cornmeal will engulf the meat and expand to be about five inches long. She says the tamales come out like they are supposed to every time.

"I've been doing this so long I would rather do it by hand than fool with a machine. These hands are good!" Susie also thinks using her hands is faster than any machine. She is one of the few remaining hand rollers left but said she wouldn't have it any other way. "I love using my hands to make hot tamales. I'll keep doing it as long as my hands let me."

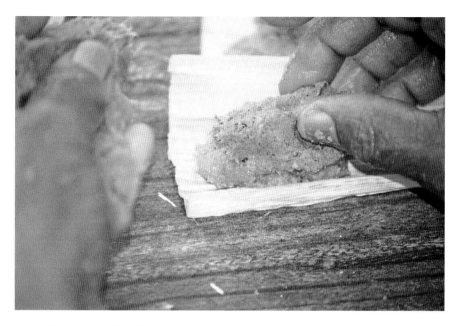

Just by feeling, Susie Ervin knows exactly how much meat and meal to place on the shuck. *Author's collection.*

For those brave and adventurous enough to try their hands at making hot tamales, here is a recipe, courtesy of the Southern Foodways Alliance and the Hot Tamale Trail. Adjust the seasonings as you like.

Mississippi Delta Tamales
Makes 7 to 8 dozen

MEAT FILLING

6 to 8 pounds boneless meat (pork shoulder, chuck roast or chicken)
¾ cup vegetable oil
¼ cup chili powder
2 tablespoons paprika
2 tablespoons salt
2 teaspoons black pepper
1 teaspoon ground cayenne pepper
1 tablespoon onion powder
1 tablespoon garlic powder
1 teaspoon ground cumin

Cut the meat into large chunks and place in a large, heavy pot. Cover with cold water. Bring to a boil over high heat. Cover the pot, reduce the heat to medium low and simmer until the meat is very tender, about 2 to 2½ hours. Remove the meat and reserve the cooking liquid. When the meat is cool enough to handle, remove and discard any skin and large chunks of fat. Shred or dice the meat into small pieces. There should be about 14 to 16 cups of meat. Heat the vegetable oil in a large, heavy pot over medium heat. Stir in the chili powder, paprika, salt, pepper, cayenne, onion powder, garlic powder and cumin. Add in the meat and stir to coat with the oil and spices. Cook, stirring often, until the meat is warmed through, about 7 to 10 minutes. Set aside.

Corn Shucks

While the meat is cooking, soak the shucks in a large bowl or sink of very warm water until they are softened and pliable, 1 to 2 hours. Gently separate the shucks into single leaves, trying not to tear them. Wash off any dust and discard any corn silks. Keep any shucks that split to the side; two small pieces can be overlapped and used as one.

Cornmeal Dough

8 cups yellow cornmeal or masa mix (available in most grocery stores)
4 teaspoons baking powder
2 teaspoons salt
1⅔ cups lard or vegetable shortening
6 to 8 cups warm meat broth (from cooking the meat)

Stir the cornmeal, baking powder, salt and lard together in a large bowl until well blended. Gradually stir in enough warm liquid to make soft, spongy dough that is the consistency of thick mashed potatoes. The dough should be quite moist but not wet. Cover the bowl with a damp cloth.

Assembling the Tamales

Remove a corn shuck from the water and pat it dry. Lay the shuck on a work surface. Spread about a ¼ cup of the dough in an even layer across the wide end of the shuck to within 1 inch of the edges. Spoon about 1 tablespoon of the meat mixture in a line down the

center of the dough. Roll the shuck so that the dough surrounds the filling and forms a cylinder or package. Fold the bottom under to close the bottom and complete the package. Do not fold the top of the tamale. Place the completed tamales in a single layer on a baking sheet. Repeat until all dough and filling is used.

Cooking the Tamales

Stand the tamales upright, folded end down, in a large pot. Place enough tamales in the pot so that they do not fall over or come unrolled. Carefully fill the pot with enough water to come just to the top of the tamales, trying not to pour water directly into the tamales. Bring the water to a boil over high heat. Cover the pot, reduce the heat to medium low and simmer until the dough is firm and pulls away from the shuck easily and cleanly, about 1 hour.

Serve tamales warm, in their shucks. Remove shucks to eat.

Recipe courtesy of Southern Foodways Alliance

Tamale Sunday

Dominick Cross

I like hot pepperoni and cool salami.
Today is Sunday—where's my tamale?
Size don't matter—ask any guy—
flavor is the savior.
I don't lie
(much)
'cuz it's Tamale Sunday.
Put it in your mouth,
one of the best damn things
about living in the South,
'cept for dancin' an' drinkin'
and fornication—or
a job with health insurance
and a paid vacation.
Still—

Tamale Sunday, tamale Sunday,
don't burn my butt come tomorrow on Monday.
But that will be then, and this is now.
Who invented tamales anyhow?
Was it Mexicans, Italians, Jews, Chinese or blacks—
A combination of them all or happenstance?
And does it really matter?
Just put it in your mouth
and taste another good reason
why we're living in the South.

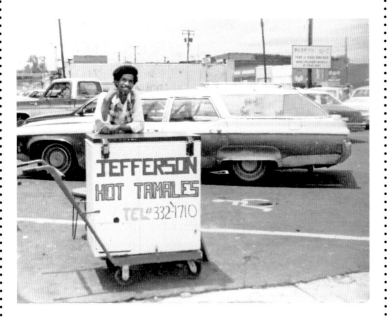

George Jefferson pushes his cart around Greenville selling tamales in the 1970s. *Gerald Jefferson.*

EPILOGUE

Over the course of the past four years, and most especially during the writing of this book, I have eaten a lot of hot tamales. And by a lot, I mean *a lot*. I was game to try anyone's hot tamale whether made and sold at home or served in a restaurant. I looked at texture, compared taste and determined if it was dry or moist. Bottom line for me was whether it tasted good and would I eat it again. And that is what a hot tamale is all about—individual taste.

I've had tamales made with beef brisket, pork, chicken, spinach, strawberries, shrimp and grits and even chocolate. Some I liked more than others. But I never met a hot tamale I didn't like. And yes, I do have my favorites, but it's up to you to decide which ones you like the best.

Hot tamales are like art. The meat is the canvas, the spices are the paint and the cornmeal or masa is the frame. And just like art is never right or wrong, neither is a hot tamale. It's a matter of personal taste and an open mind. I've seen folks take one look at a tamale and shy away with exclamations of "What is that?" and "Ew!" But like anything new, you don't know if you like it if you don't try it. And everyone should try a hot tamale at least once. Beloved hot tamale maker and former king of the Hot Tamale Festival Shine Thornton knew this and believed it so much he tried for years to get his hot tamales delivered to the White House.

Hot tamales are one of the few foods made where hands touch every single morsel. No matter how you cook the meat, hands are used to put the mixture into the tamale machine or form them by hand. And hands are

used to roll this beloved Delta delicacy into the corn shuck. Those hands are continuing a tradition that could quite possibly be thousands of years old.

As I traverse the Delta, I find myself looking for hot tamale signs. I'm drawn to them not because I'm searching for the best tamale out there but because they are all different and I want to taste the difference and to find out that tamale's story. Along the way, I bring home tamales to share. Every good, self-respecting Delta home has a box of fresh saltine crackers in the cupboard ready for the unexpected arrival of a couple dozen hots.

Tamales also carry the stories of those who make them. Those stories are our stories—the Delta's stories. And that is just one more reason I love the Delta. Our stories are colorful, maybe slightly embellished, but full of soul and truth. We love to share our stories of the river, the land, big bucks and whiskered fish. Family is sacred, and mealtime is serious business. We never meet a stranger and go out of our way to make sure they have sufficient food and liquid refreshment, be it sweet tea or brown whiskey. A cold beer and glass of Pinot Grigio will go great with those tamales.

And somewhere along the way, hot tamales will enter the conversation and land on a plate in front of you. You don't have to wait to be invited to try them. Go ahead, unroll one of the most talked-about but mysterious foods to ever find its way into our culture.

Hot tamales are as magical as the Delta.

And don't forget, you can't say hot tamale without smiling. Enjoy!

INDEX

INDEX

ABOUT THE AUTHOR

Anne Martin grew up in the middle of the hot tamale epicenter, Greenville, Mississippi. She is an award-winning journalist, having spent thirty years in broadcast news. She is now a writer, documenting the stories of her beloved Mississippi Delta, and is a regular contributor to *Life in the Delta* and *Eat. Drink. Mississippi.* Anne is a co-founder of the Delta Hot Tamale Festival. She lives in Rosedale, Mississippi, where she continues to enjoy Delta hot tamales.